Scenes from the Country Fair

MICHAEL P. GADOMSKI

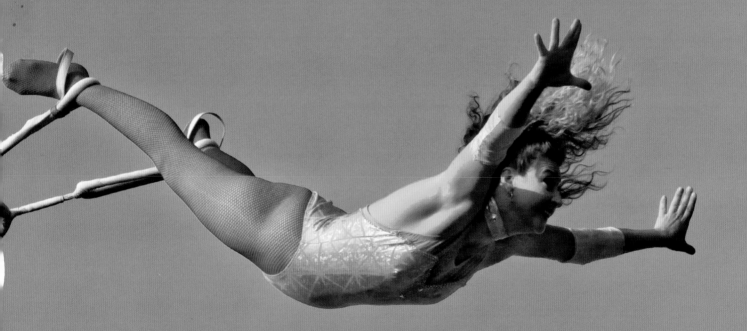

Schiffer Publishing Ltd

4880 Lower Valley Road · Atglen, PA 19310

Copyright © 2018 by Michael P. Gadomski

Library of Congress Control Number: 2017955193

Cover design by Ro
Type set in Gill Sans/Itsadzoke

ISBN: 978-0-7643-5480-9
Printed in China

Published by Schiffer Publishing, Ltd.
4880 Lower Valley Road
Atglen, PA 19310
Phone: (610) 593-1777; Fax: (610) 593-2002
E-mail: Info@schifferbooks.com
Web: www.schifferbooks.com

For our complete selection of fine books on this and related subjects, please visit our website at www.schifferbooks.com. You may also write for a free catalog.

Schiffer Publishing's titles are available at special discounts for bulk purchases for sales promotions or premiums. Special editions, including personalized covers, corporate imprints, and excerpts, can be created in large quantities for special needs. For more information, contact the publisher.

We are always looking for people to write books on new and related subjects. If you have an idea for a book, please contact us at proposals@schifferbooks.com.

This book is dedicated to today's 4-H and FFA youth,
tomorrow's agrarians, who will be facing the difficult challenges of
feeding a rapidly growing world population using sustainable and
environmentally compatible farming methods.

INTRODUCTION

★ ★ ★

I had always assumed
that everyone has visited a country fair
at some time in their lives.
But I was wrong.

Arriving a little early to a small country fair in eastern Pennsylvania, my wife and I waited in a short line for the gates to open. Next to us in line was a couple from an urban area outside Philadelphia who were vacationing in the area. We soon found ourselves making small talk with the couple, who acknowledged that they had never been to a fair and asked, "What do you do at a fair?"

My wife and I were taken aback. How do you answer that? Well, I guess you can say, you see new things, see old things, learn a few things, see old friends, make new friends, eat—and, boy, can you eat—check out the livestock and exhibits, check out the people, see the shows, maybe try your skill at Whac-a-Mole, and basically just have a whole lot of fun. But to say these things to someone who has never been to a country fair would not make sense. You must experience it to understand.

For a kid growing up in the country, the fair ranks right up there with Christmas and the last day of school before summer vacation. And if in springtime a young man's fancy turns to love, surely in late summer it turns to the fair. When I was in elementary school, our local county fair was held in September, about a week after school began. Because agriculture was an important industry, classes were canceled for one day and every school kid got a free pass to the fair. The schools donated their buses to transport us. And with the dollar or two in our pockets we had

earned during the summer break, or that our parents gave us, with strict orders not to waste it on games, off we went for a day of fun with our closest pals.

Oh, the sights we saw, the food aromas we smelled! Everything was a wonder, and the temptation not to spend our meager bankroll in the first half hour seemed to require biblical restrain. As far as those strict orders not to waste our money on games, it always came down to, "I won't tell your mom, if you don't tell my mom."

Just like everyone is Irish on Saint Patrick's Day, everyone is country during fair week. Jeans, cowboy hats, and western boots are the conventional fashion even if the rest of the year is spent in office attire. Not so long ago, America was an agrarian-dominated society. According to the 1910 census, 54.2 percent of the United States population was rural. As late as the 1950s, it seems everyone had at least one relative who farmed. Those rural traditions are strongly embedded in our consciousness, and the country fair is a way people connect with their roots.

There are roughly 3,200 agricultural fairs held every year in the United States. This includes forty-seven state fairs, but those are large commercial events. It is the local and county fairs that are about community and the grassroots of America.

To photograph all these fairs would take several lifetimes. This book focuses on thirteen county and local fairs in eastern and central Pennsylvania, and they are fairly representative of fairs across the US. Every fair has something unique to offer, yet they have many things in common.

A country fair is not the same as a firemen's carnival, nor are they art, craft, street, or trade fairs, although all of these elements may be part of it. Fairs began as a place to exhibit innovative and best practices in agriculture and animal husbandry, and in turn to help the young nation become less dependent on foreign imports. Many agricultural colleges played an important role in their states' country fairs, and still do.

The first North American fair is believed to have occurred in Windsor, Nova Scotia, in 1765, and the first United States fair was held in Pittsfield, Massachusetts, in 1807. Yet the York County Agricultural Society in Pennsylvania claims the distinction of being the first agriculture fair in America. In 1765, York received a charter from Thomas Penn, son of William Penn, in recognition of "the flourishing state to which the town hath arrived through their industry," and a two-day agricultural market was held on the town commons. History suggests that during the American Revolution and the War of 1812, troops passing through York camped at the commons, sharing the grounds with the fair. In 2015, the York Fair celebrated its 250th anniversary, making it eleven years older than the United States.

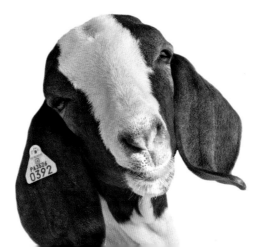

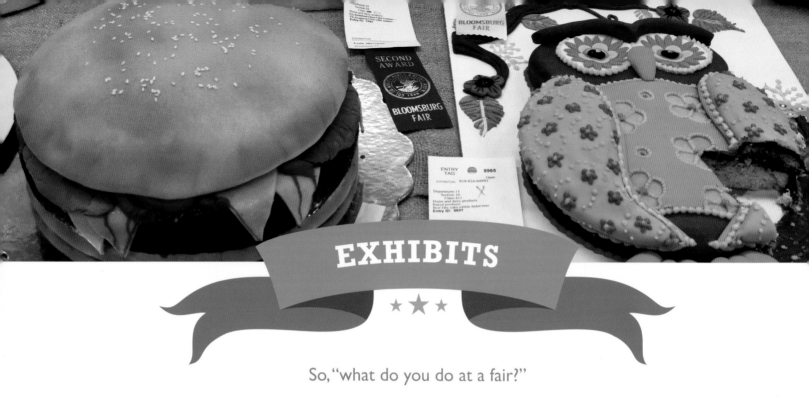

So, "what do you do at a fair?"

Generally the rides and midway entertainment don't get underway until late afternoon, so it's a good idea to arrive early to check out the exhibits. The competition for biggest pumpkin or best apple pie often pits neighbor against neighbor; this friendly rivalry often continues for years or even generations. It starts in the dead of winter with the right seeds from seed catalogs and choosing the perfect quilt design, all of which are kept secret until fair day using methods that would make the CIA proud.

After the fairs release their premium books listing the exhibit divisions and prize money for each category, the entries start to materialize. The best fruits and vegetables are given special care as they grow in the gardens. The best canned goods and preserves are set aside, and each stitch in every textile craft is carefully examined, sometimes with a magnifying glass. Baked goods are made several times, until the recipe is perfected for the final baking just before the fair.

To the untrained eye, the agriculture and craft exhibits may just seem like a collection of items found in department stores or supermarkets. But to the judges and those in-the-know, the subtle differences are apparent. Reputations are at stake. Many farmers who sell their produce at farm stands or farmers markets display their ribbons to tout the quality of their products. And there is always that chance that your entry will catch the eye of a reporter from the local newspaper, television station, or even a regional or national magazine.

The country fair is a regional snapshot. You might find pecans in southern fairs, while in the north Christmas tree growers show off their artfully pruned conifers. Other areas may feature wines, grains, citrus, maple syrup, or blueberries.

One or two people usually man the exhibit halls, stationed at each entrance to protect the displays from any harm. These hall monitors are usually volunteers from local churches or other organizations and work in two-hour shifts. The fair committee pays the church or organization for the service, contributing back to the local community.

For clubs and collectors, fairs are a great venue for showing off their passions and interests, especially farm-related. It is a rare fair that doesn't have an exhibit of antique tractors whose owners are more than willing to talk about their proudly restored machines. And there is always a local group demonstrating stationary antique farm engines with their characteristic "putt-putt-putt-putt-BAM" sound.

Many established fairs have a fair museum documenting the history of the fair or region, including artifacts from attics or ancestral barns. Rather than ending up in a landfill, these relics tell the story of both good times and hard times and the evolution of society.

The next stop may be the commercial building where all sorts of merchandise and services can be found for sale. Everything from rain gutter leaf guards to tombstones, natural-ingredient homemade soaps, penny candy, sunglasses, fancy cowboy hats, Bibles, and hot tubs are offered for sale. Many government agencies, service organizations, and political parties also set up displays. Some of the more relevant organizations displaying here are the 4-H clubs, the FFA (Future Farmers of America), and the Grange, along with the state's agricultural extension service.

FOOD
★ ★ ★

What do you eat at a country fair?

Anything you want! Temptations abound with sausage and pepper sandwiches, cheesesteak sandwiches, gyros, pizza, hot dogs, baked potatoes, corn dogs, haluski, pierogies, barbecue chicken-on-a-stick (or anything else on a stick), French fries with vinegar, funnel cakes, cotton candy, candy apples, monkey bread, blooming onions, onion rings, and bacon-wrapped, chocolate covered, or deep-fried anything. Some people go to the fair just for the food, although few will come right out and admit it. This is, after all, the time to pig out on food you don't find all in one place any other time of the year.

Although fair food has an artery-clogging reputation, some fairs have a cafeteria run by a local civic group that offers delicious homemade food at an excellent price. Many church and civic organizations have permanent food concession buildings at local fairs to raise funds. Their members maintain and operate these concessions during fair week. In some cases, this may be the organization's biggest fund-raiser of the year. Of course, if you are a member of a particular church or organization represented, you must patronize its concession stand, even if you don't like the food, and always praise the hard-working volunteers. This is also a great opportunity to share gossip with old friends and neighbors.

Friendly rivalries break out here, too. Do the Lutherans or the Catholics make the best potato pancakes? Whoever it is, you must never cross party lines, unless of course you are part of a mixed marriage and then you must visit both, but never critique the other to keep the marriage running smoothly.

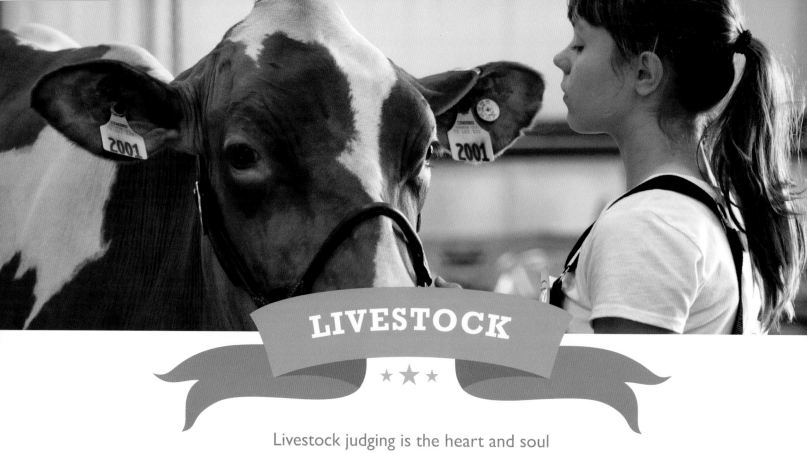

LIVESTOCK

★ ★ ★

Livestock judging is the heart and soul
of the country fair.

This was the genesis of agriculture fairs, farmers gathering to compete with neighbors and learn more productive ways of farming. Today, livestock judging is focused on the youth—4-H and FFA members, tomorrow's agrarians.

Months before the fair, 4-H and FFA members select a project. It might be a dairy cow, swine, poultry, sheep, goats, rabbits, or any other livestock. These animals are not their pets and are often auctioned off at the end of the fair. The youth develop skills in animal husbandry, showmanship, agribusiness, and marketing, along with a work ethic that lasts a lifetime. It offers an opportunity that few urban kids have.

During the period leading up to the fair, the animals must be fed, watered, groomed, and exercised daily to build muscles, as though they were entering a beauty contest, and their stalls cleaned frequently. The youth must form a bond with their animal through constantly practicing the skills of handling and showmanship so that during judging both animal and handler know how to behave.

Today, in some quarters, youth livestock judging is done with expensive stock purchased from specialized breeders. These animals are readied in a few short weeks for high-stakes judging and auctions on regional and state levels. However, most participants at local and county fairs use their family's own developed livestock.

Judges are looking not just at the animals, but at the handler's showmanship skills. That includes appearance, clothing, grooming, concentration, control, and knowledge of the animal. The handler must always face the judge, no matter how many times the judge turns or changes direction while walking around examining the row of livestock. Many fairs have a showmanship competition where each youth must present several different types of livestock in

succession. Tensions run high and often tears are shed from disappointment and joy. Studies have shown that 4-H and FFA members are less apt to shoplift, use illegal drugs, damage property, consume alcohol, or smoke, while at the same time making more positive contributions to their communities and to themselves than non-members. They develop respect for themselves and others.

Each animal class is judged on its own merits. Dairy cattle are judged differently than beef cattle. Beyond that, judges are looking for cleanliness, grooming, posing, attitude, and, most important, marketability. After the judges examine every animal, they explain to the audience the qualities they see in each animal and how they are being judged. Blue ribbons are handed out for first place, red for second place, and yellow for third place. A grand champion might get a purple ribbon. Then the winners pose for a group photograph with the fair queen.

But the reward is not just a ribbon or a small amount of money. Near the end of the fair, a livestock auction is held for those who want to participate, and it is here where real money is made, partly to recoup the cost of raising the animal, but also to invest in new livestock or save for college. The ribbon winners receive the top bids, and their hard work pays off.

MIDWAY

★ ★ ★

As the sun sets and the lights come on,
magic happens.

The midway comes into its glory and the fun begins. The lights, the sounds, the rides to dare your nerve, and the carnies luring you to try your luck at their game all add to the excitement. At a local fair, this is where you are almost certain to run into old friends.

At one time, sideshows and freak shows were a big part of the midway. These have mostly faded into history as our evolving culture has made them less appealing. There are still some family-oriented sideshows featuring jugglers, magicians, and animal and musical acts.

Another relic of the past are "girly-shows." Local laws and ordinances put a stop to many, then the Internet dealt the final blow. Yet at one time they were an accepted part of the fair, even though some people highly disapproved.

A few years ago, while walking the midway at our local fair, my wife and I ran into old friends. Bucky is a well-loved local minister, and while our wives chatted, I mentioned the girly-shows of our youth. Bucky claimed he didn't remember them. I described how as teenagers we would lie about our age to get into the shows. I saw Bucky's blank stare and wondered how could he have missed them, as they were notorious. It was only years later, after I learned never to play poker with him, that he confessed that not only did he know about the girly-shows, but that he had snuck under the tents to see them, making him a superhero of sorts among his peers. It was a rite of passage in its time.

Carnies are a subculture in their own right and have their own vocabulary. And while most carnies and their games are honest, you might occasionally find a "grafter" who is on the lookout for a "mark," especially a "lugen" in the "tip" to get them into their "joint" so they can "crank" them while "joing" the game. In 1969, Joni Mitchell romanticized this world with "That Song About the Midway," which was about falling in love with a carnie. Today several carnies claim the song was written about them.

The midway is the place where memories are made. Who remembers being held by one of your parents as you rode the wooden horse for the first time on the merry-go-round? And getting cotton candy all over your face? Later you walked the midway with your cool-dude pals knowing you could conquer every daredevil ride without the slightest bit of fear. In a few short years your pals were replaced by that special girl with whom you held hands and snuck a kiss when you thought no one was looking. Before you knew it, you were holding your own child for their first merry-go-round ride. Then, in what seems like a flash of time, you are sitting on the bleachers watching a young boy with a neatly pressed shirt, fresh haircut, and clean jeans proudly holding a beautifully groomed goat with its head held high and tail erect. Blue and red ribbons dangle from the boy's back pocket. You turn to the stranger sitting next to you and proudly say, "That's my grandson."

It's certain that five-year-old Noah Ritter will never forget his visit to Pennsylvania's Wayne County Fair, where he was interviewed by WNEP-TV reporter Sofia Ojeda. Noah grabbed the microphone, took over the interview, and "apparently" charmed the world describing his experience at the fair. When the video clip went viral, he was booked for appearances on Good Morning America, The Today Show, Jimmy Kimmel Live!, and The Ellen DeGeneres Show. He was even hired to star in a pet food commercial, all because of a day at the fair with his grandfather. Noah's interview can be seen at wnep.com.

<div align="center">

What do you do at a fair?
The answer is simple: just show up and the fair will take care of the rest.

</div>

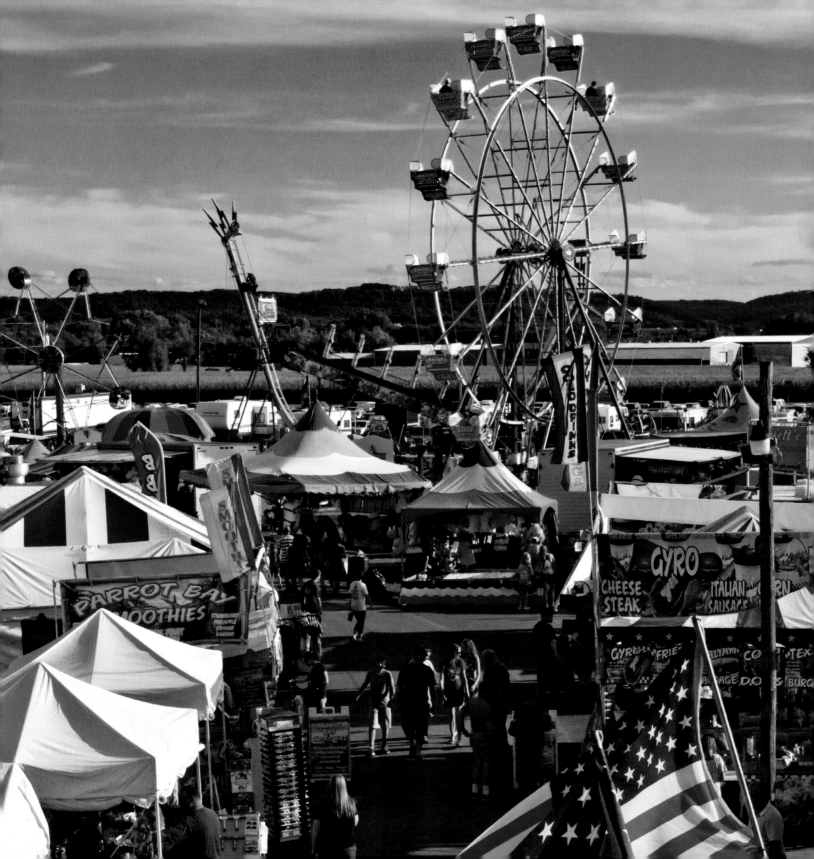

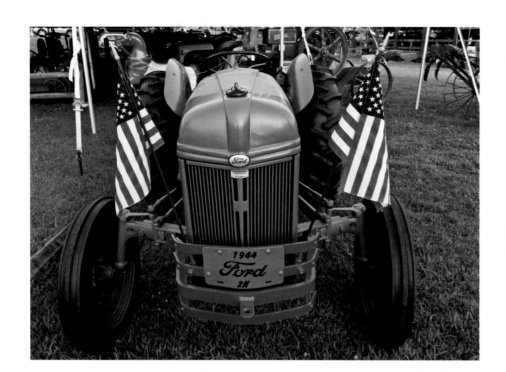

LEFT
This classic WWII-era
1944 Ford 2N tractor at the
Berks County Fair originally
sold for $1,120.00.

BELOW
Sewing is a popular craft at the
Lebanon Area Fair.

OPPOSITE
A smiling, pumpkin-headed
scarecrow braves a few raindrops
at the Hartford Fair.

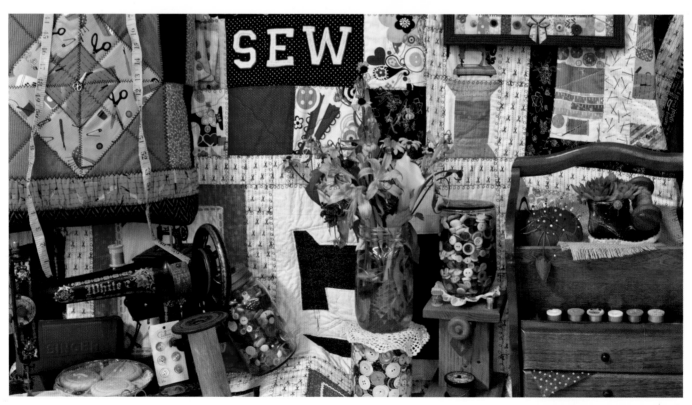

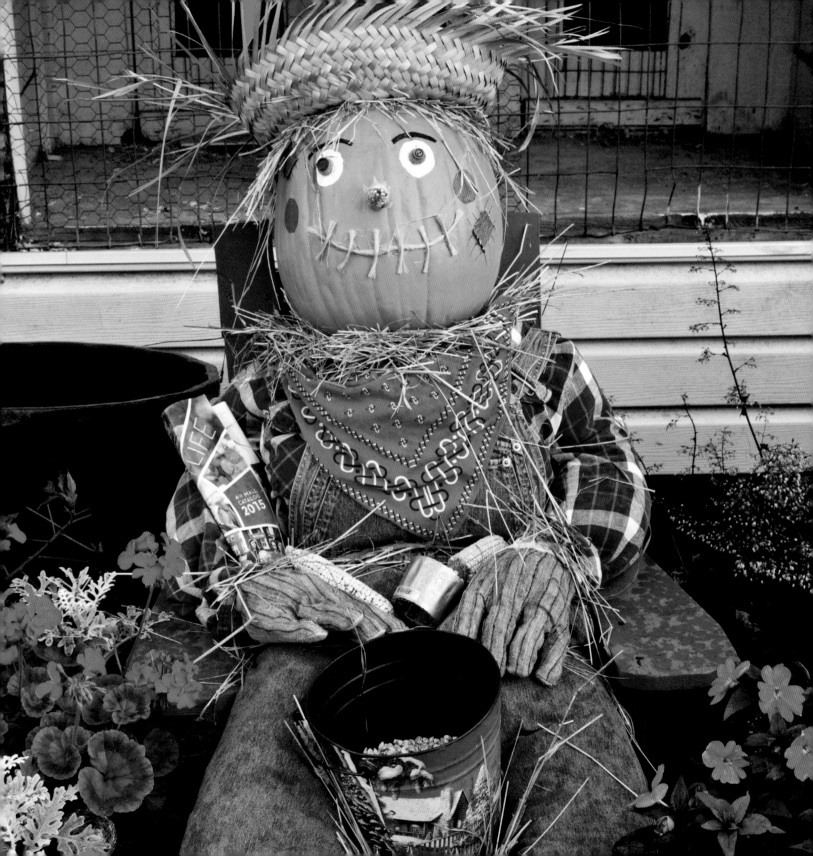

14

The Grange, or the National Grange of the Order of Patrons of Husbandry, was founded in the mid-nineteenth century to advance agricultural methods while asserting that the farmer is the central character upon which all society relies.

BELOW
A potpourri of vegetables grown by local farmers and gardeners is displayed at the Hartford Fair.

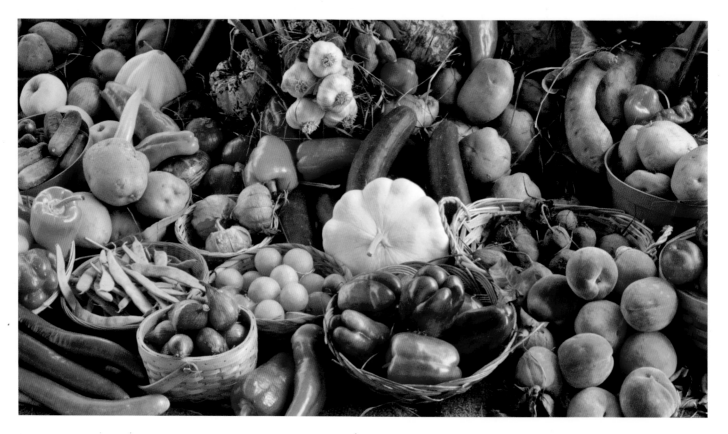

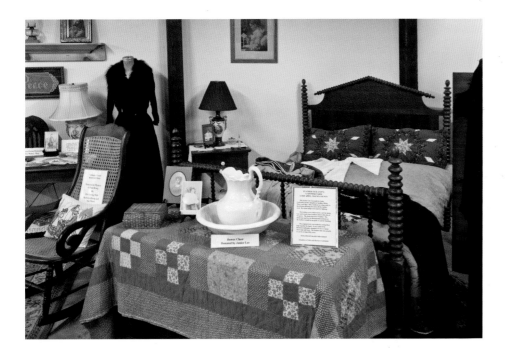

LEFT
Articles from late-nineteenth and early-twentieth-century rural bedrooms, including a 1920s feather tick made by the author's grandmother and aunts, are preserved in the West End Fair Museum.

BELOW
A mid-twentieth-century country kitchen table and a seed catalog featuring three "local girls" on the cover is displayed at the West End Fair.

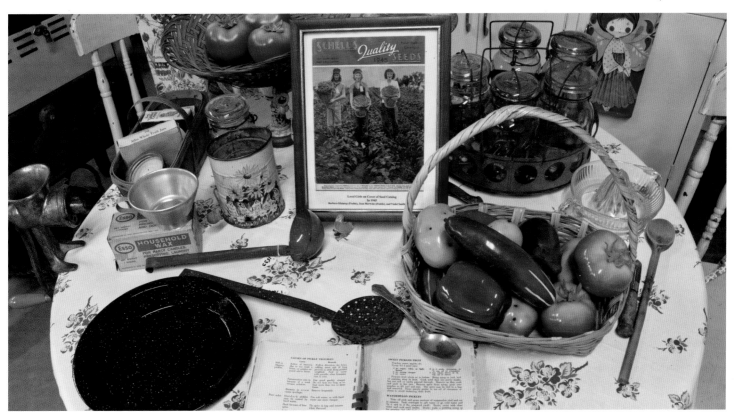

RIGHT
A fine collection of promotional yardsticks at the West End Fair recalls a decades-long local business tradition.

BELOW
Historic farm implements and a restored 1850 farm wagon are displayed in the Hartford Fair's Founder's Museum.

OPPOSITE
WWII memorabilia donated by local veterans and their families are displayed in the West End Fair Museum in Gilbert, Pennsylvania, recalling the sacrifices and service of "the greatest generation".

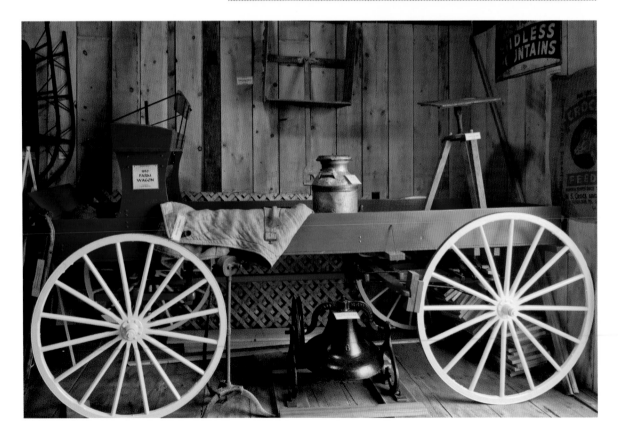

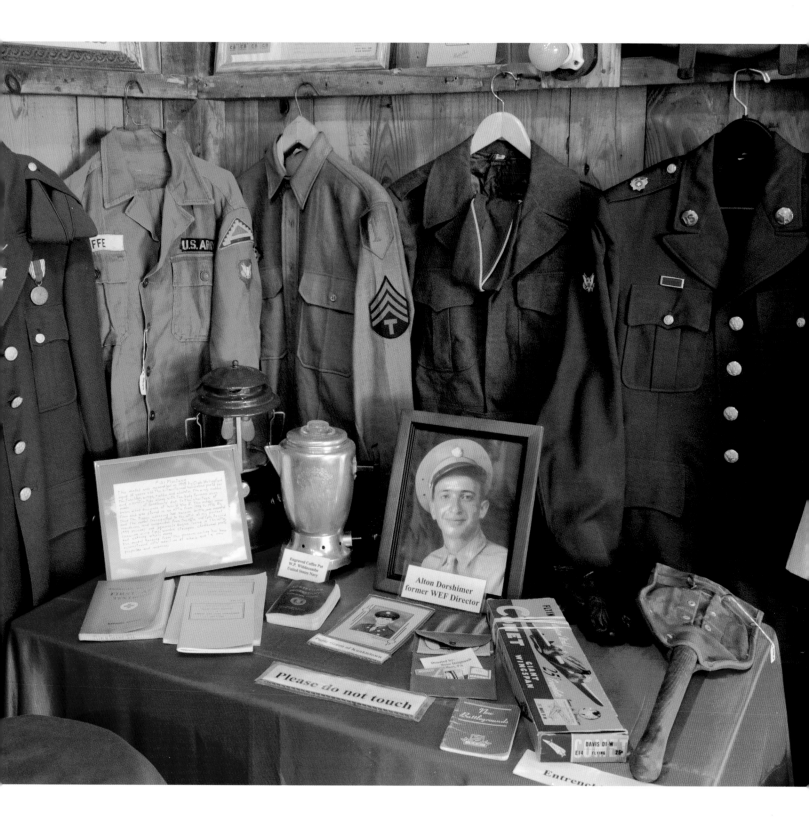

Engraved Coffee Pot
W.F. Widdemaier
United States Navy

Alton Dorshimer
former WEF Director

Please do not touch

GIANT
COMET
WINGSPAN

DAVIS DI W
E14 FLYING 25¢

Entren

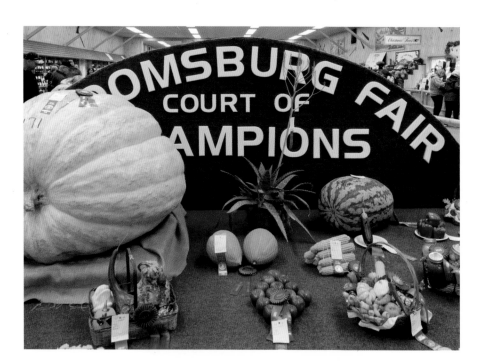

LEFT
The Court of Champions
at the Bloomsburg Fair includes a
1,171-pound pumpkin.

BELOW
Cleverly created scarecrows at the
Bloomsburg Fair imitate a lighthearted
stereotype of rural life.

OPPOSITE
An attractive collection of pumpkins,
squash, and gourds is displayed at the
Allentown Fair.

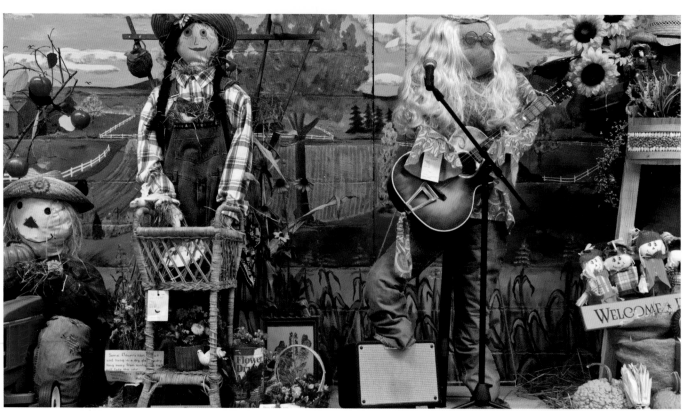

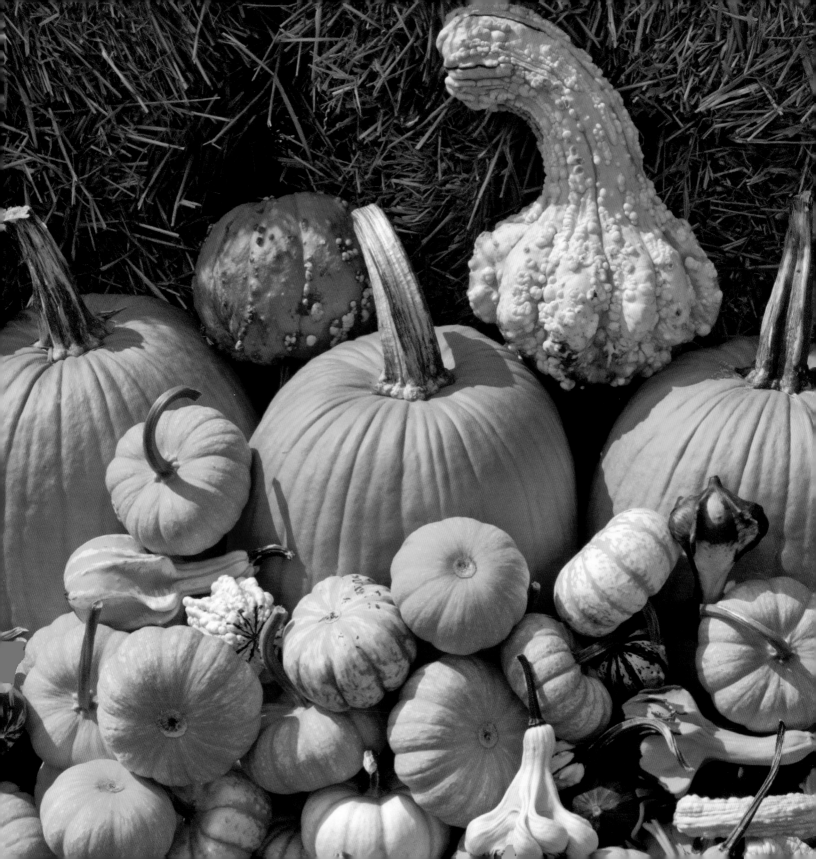

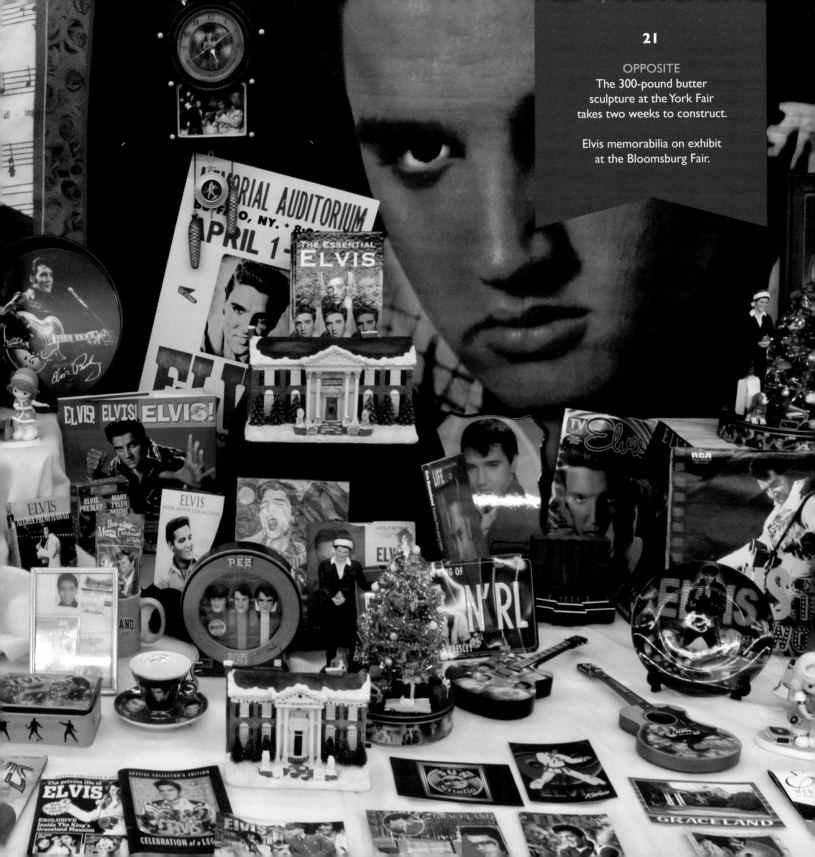

OPPOSITE
The 300-pound butter
sculpture at the York Fair
takes two weeks to construct.

Elvis memorabilia on exhibit
at the Bloomsburg Fair.

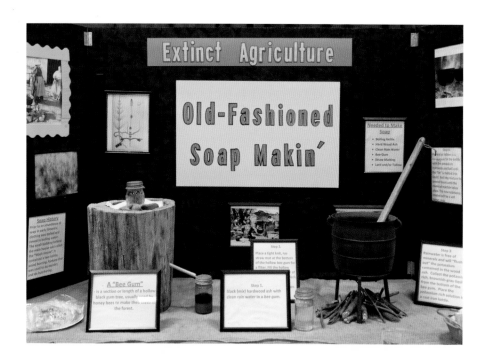

LEFT
The nearly forgotten art of soap making is explained at the Allentown Fair.

BELOW
Milk glass displayed at the Bloomsburg Fair is popular with collectors.

OPPOSITE
Antique farm hand tools at Wayne County's Greene Dreher Sterling Fair in Newfoundland, Pennsylvania, include rare drawknives, broad axes, shingling hatchets, and garden seeders.

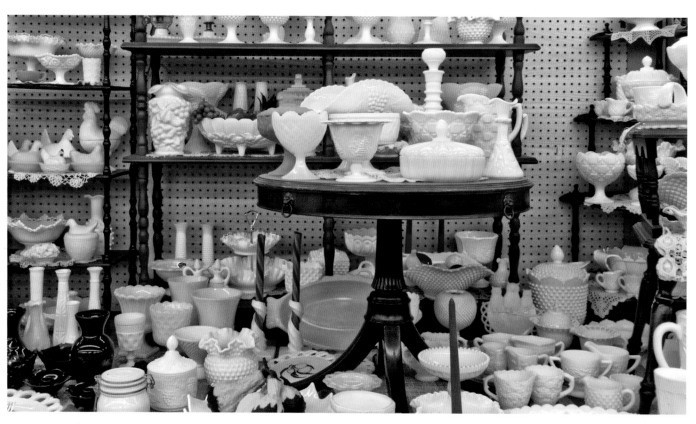

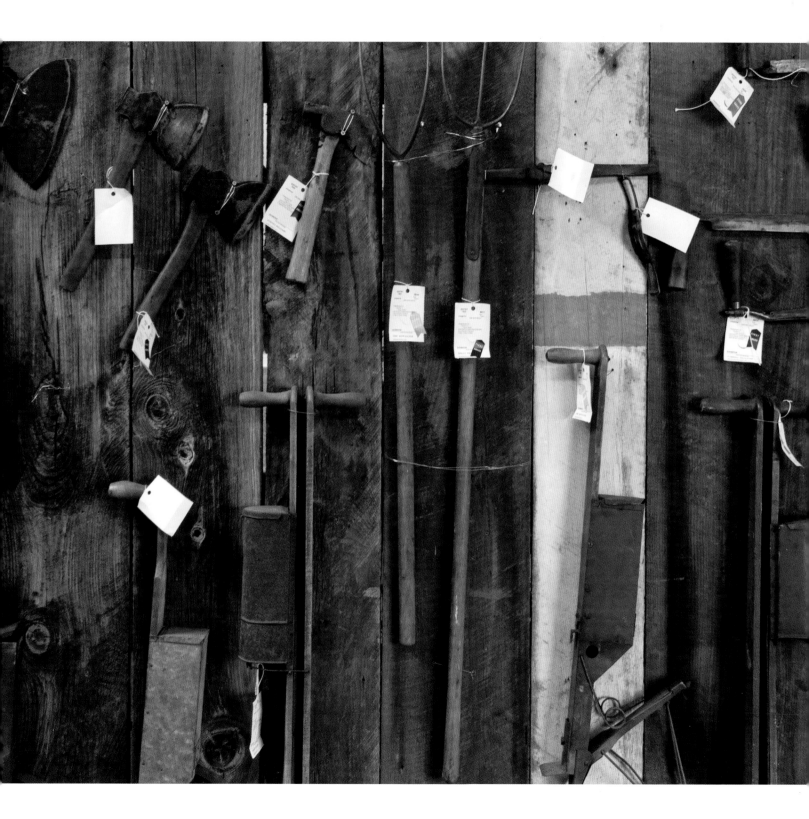

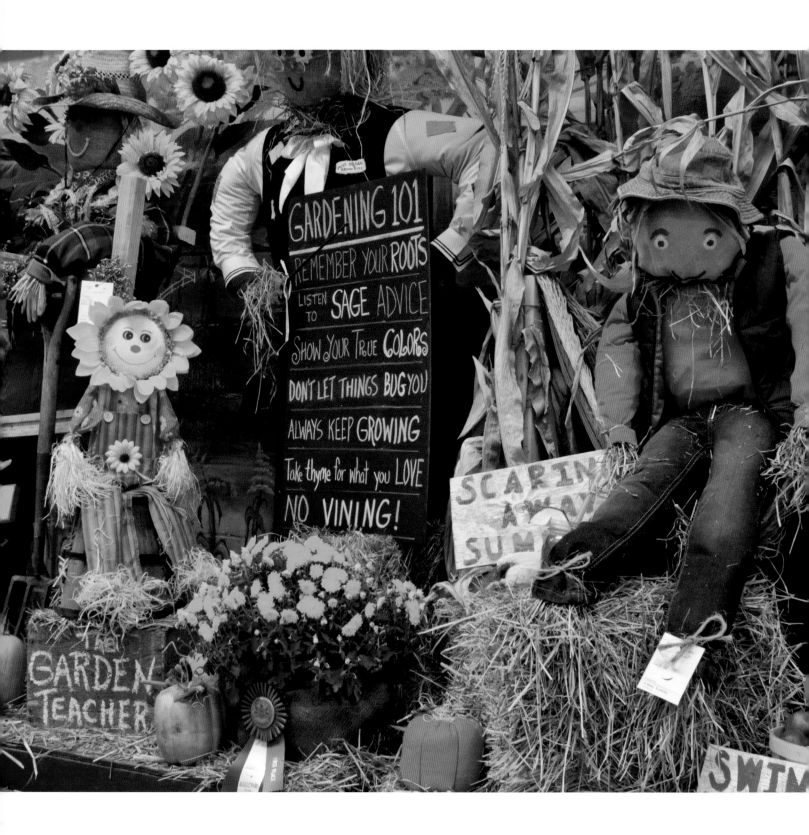

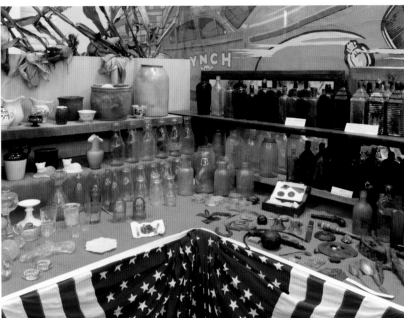

OPPOSITE
A scarecrow exhibit at the Bloomsburg Fair teaches gardening skills.

LEFT
Antique bottles and glassware at the Bloomsburg Fair were dug from century-old outhouse pits.

BELOW
Happy scarecrow faces provided by the Bloomsburg High School delight visitors at the Bloomsburg Fair.

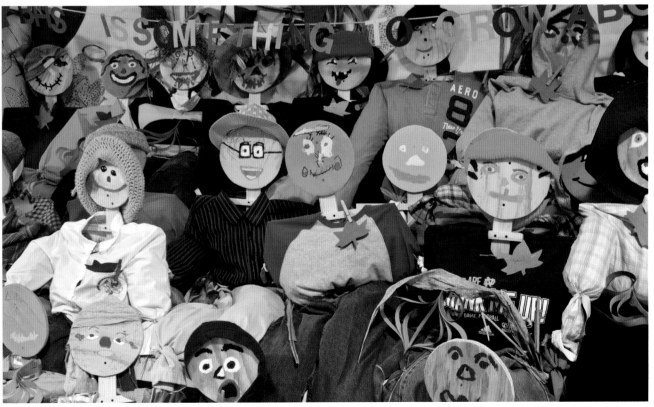

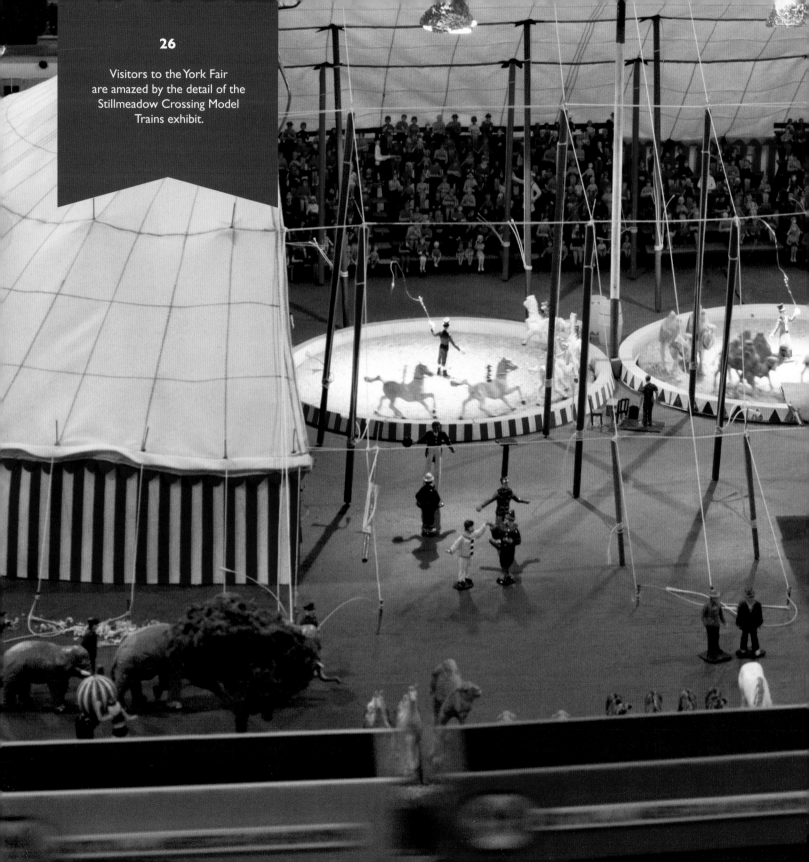

Visitors to the York Fair are amazed by the detail of the Stillmeadow Crossing Model Trains exhibit.

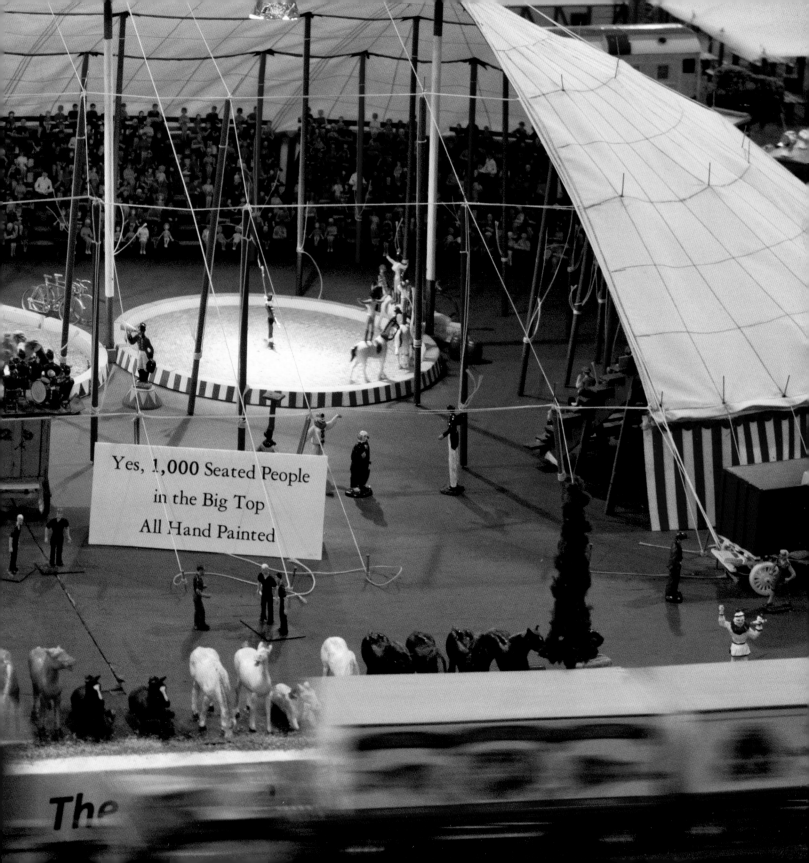

Yes, 1,000 Seated People
in the Big Top
All Hand Painted

The

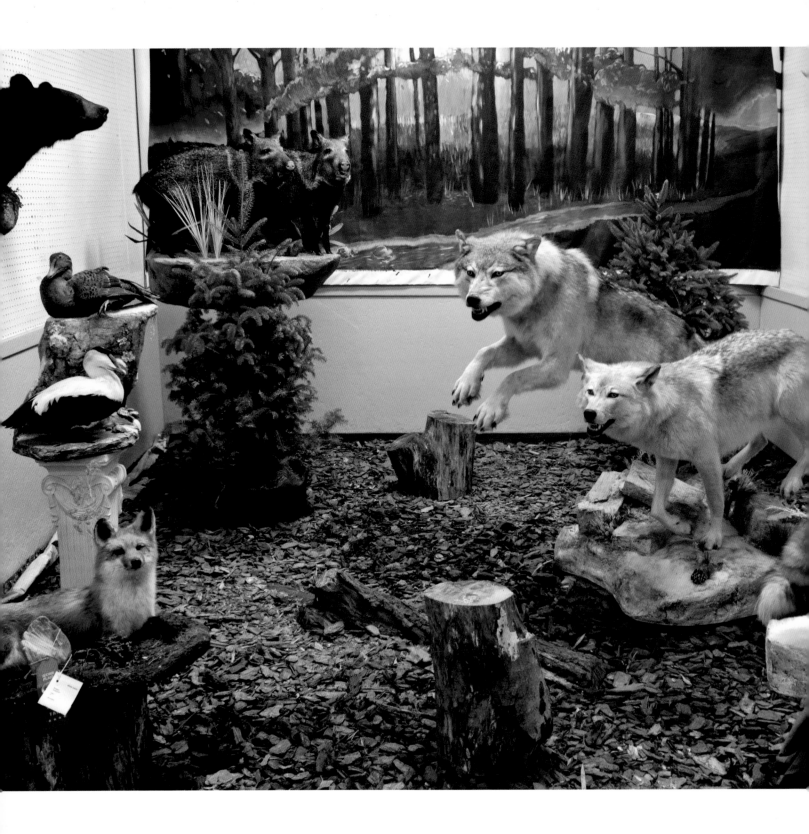

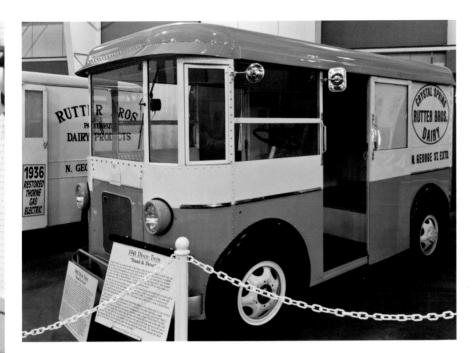

OPPOSITE
The art and craft of taxidermy is judged and exhibited at the York Fair.

LEFT
A beautifully restored 1941 home delivery milk truck is exhibited at the York County Fair. Once a common sight, milk delivery trucks are now virtually gone from the American landscape.

BELOW
A beautiful display of vegetables from a home garden wins second place at the Bloomsburg Fair.

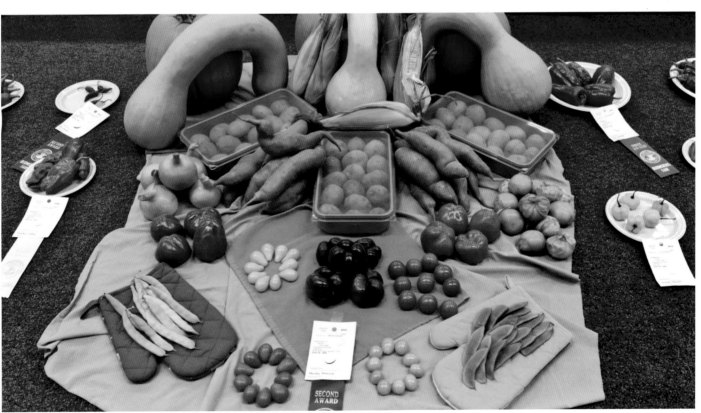

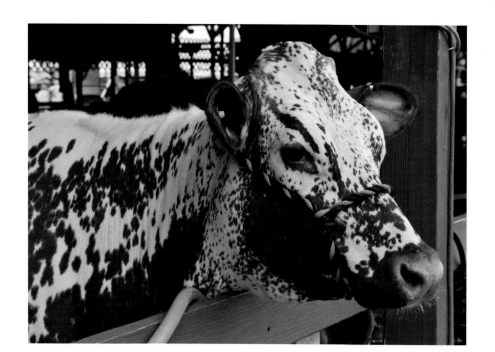

LEFT
A rare Randall Lineback dairy cow appears to enjoy an afternoon of people watching at the Reading Fair.

BELOW
Some of the winners in the 4-H dairy judging at the Lebanon Area Fair pose with the Lebanon County Dairy Princess and Lil' Dairy Miss.

OPPOSITE
City learns from country at the Carbon County Fair.

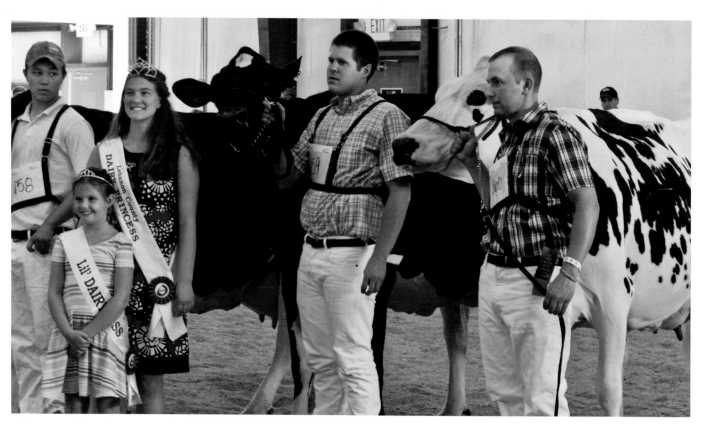

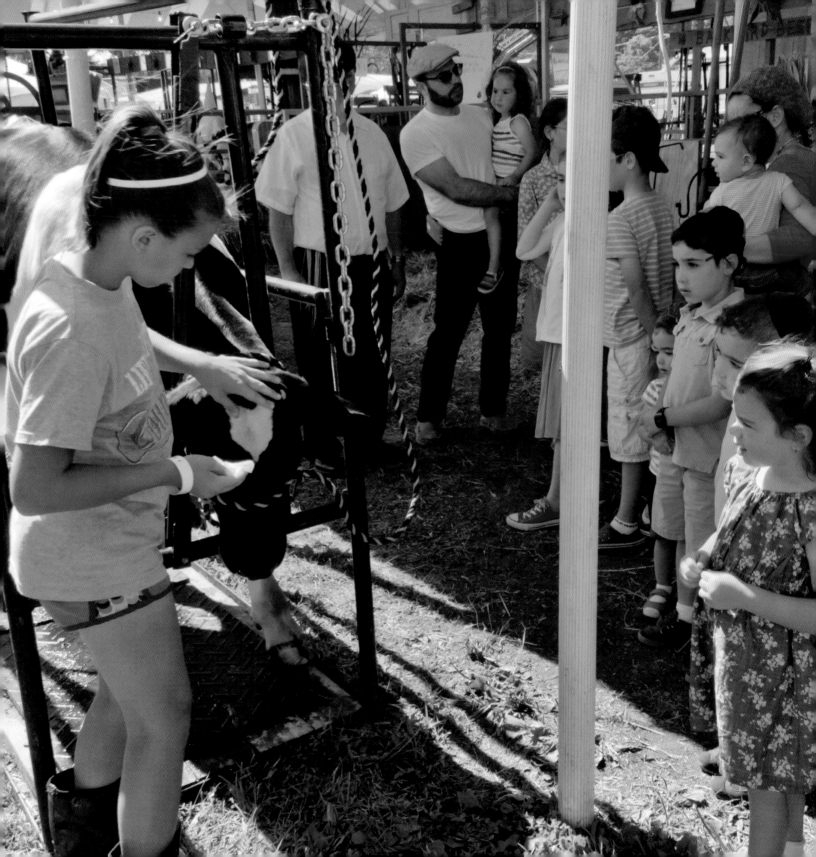

LEFT
The competition becomes tense during the 4-H goat judging at the Wayne County Fair.

CENTER
A Highland calf appears to enjoy being part of the petting zoo at the Lycoming County Fair.

RIGHT
The grand champion in the 4-H market lamb competition at the Carbon County Fair proudly displays its purple ribbon.

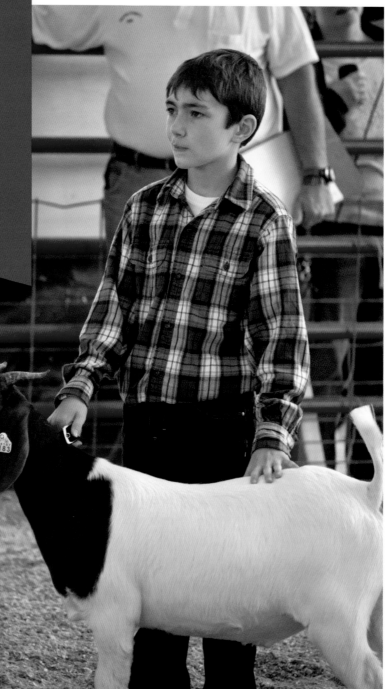

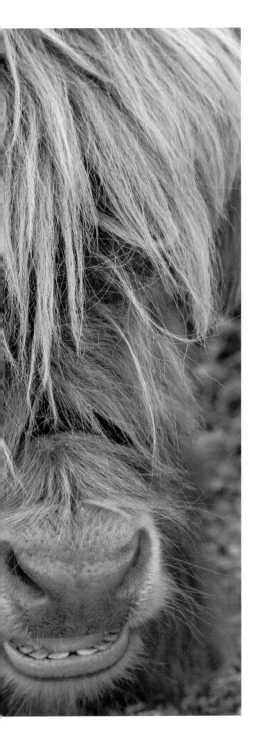

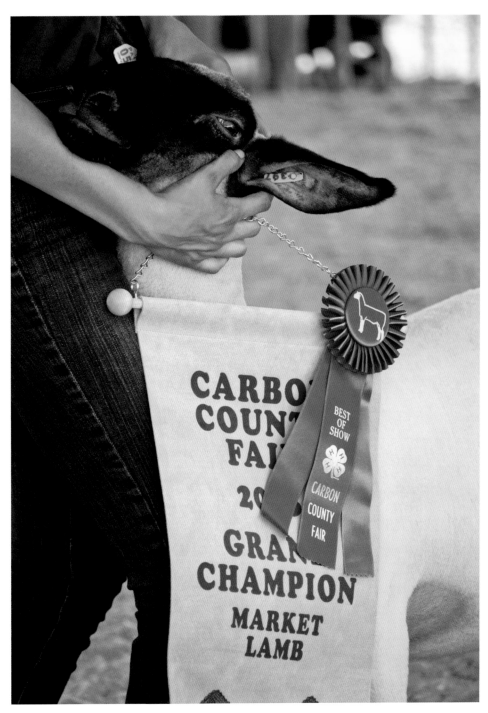

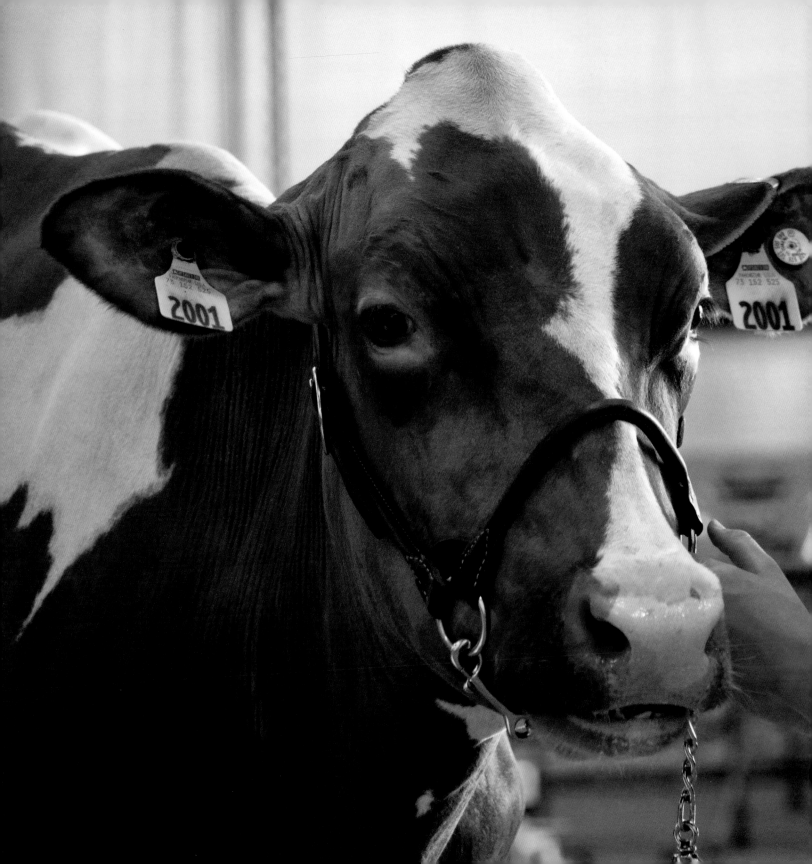

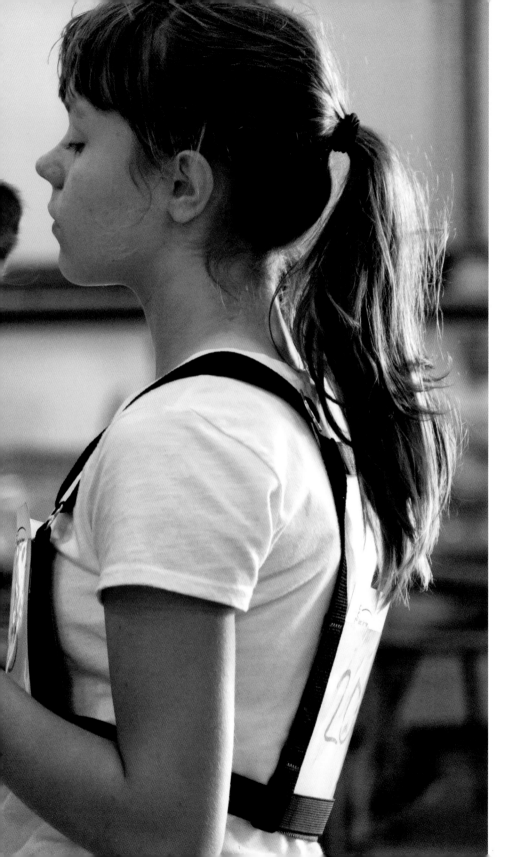

A young 4-H member waits with her well-groomed Guernsey dairy cow at the Lebanon Area Fair.

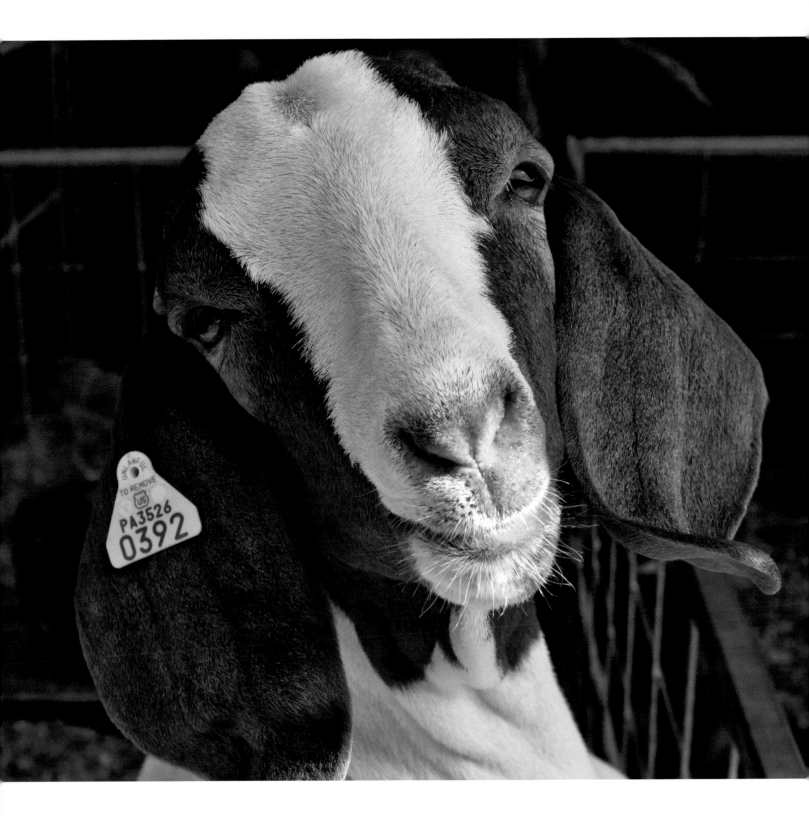

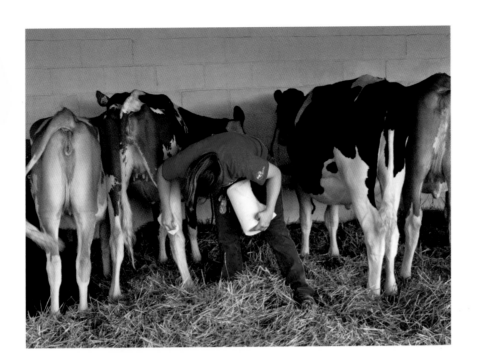

OPPOSITE
Just another friendly face at the Kutztown Fair.

LEFT
A heifer gets a last-minute spot cleaning before the Kutztown Fair judging begins.

BELOW
A young Holstein bull calf gets a quick shower before show time at the Berks County Fair.

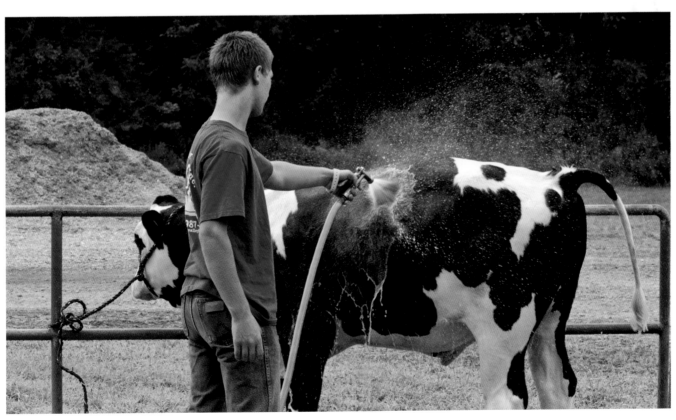

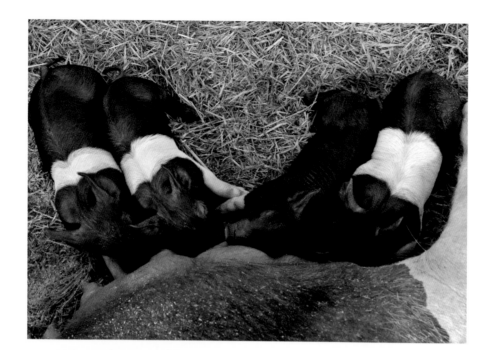

LEFT
Dinnertime for a litter of piglets
at the Kutztown Fair.

BELOW
A walk to the Harford Fair corral
for some daily exercise and
practice.

OPPOSITE
A contestant receives advice on
how to trim his sheep before
judging at the Hartford Fair.

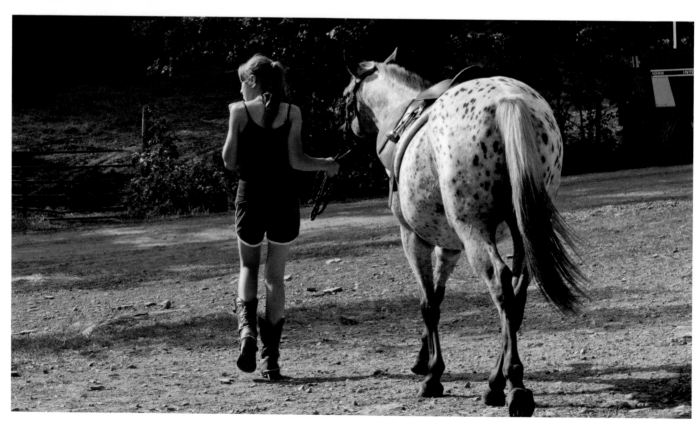

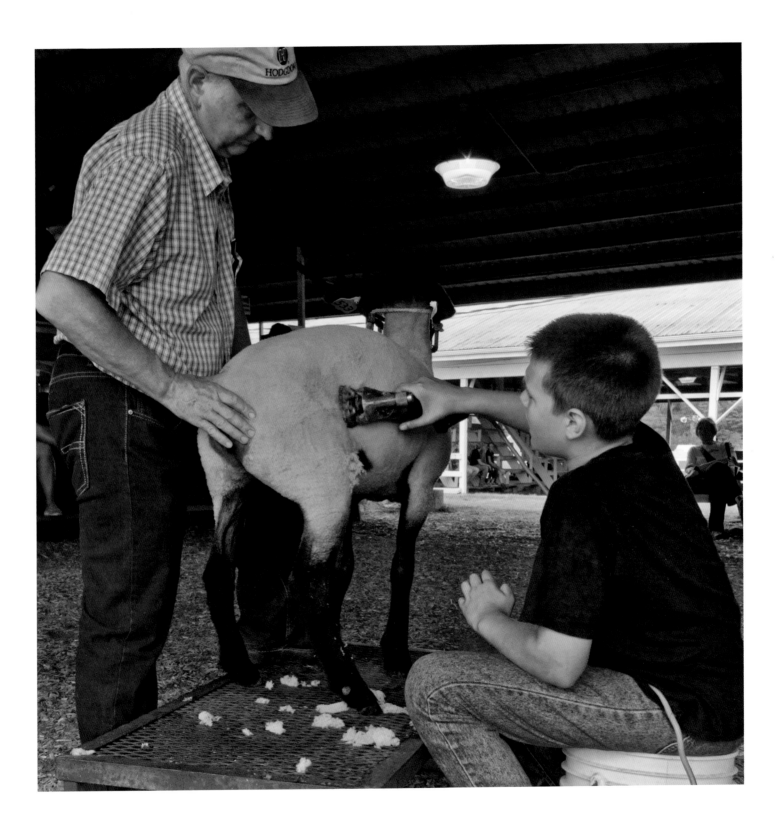

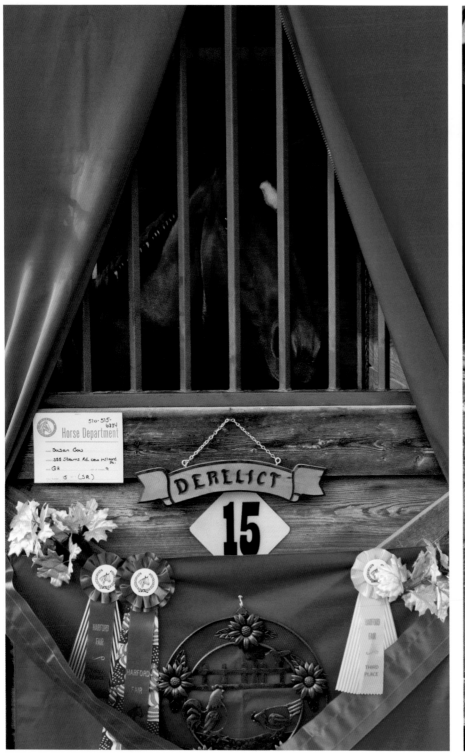
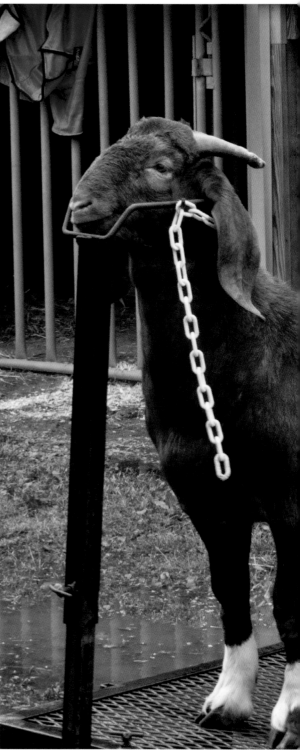

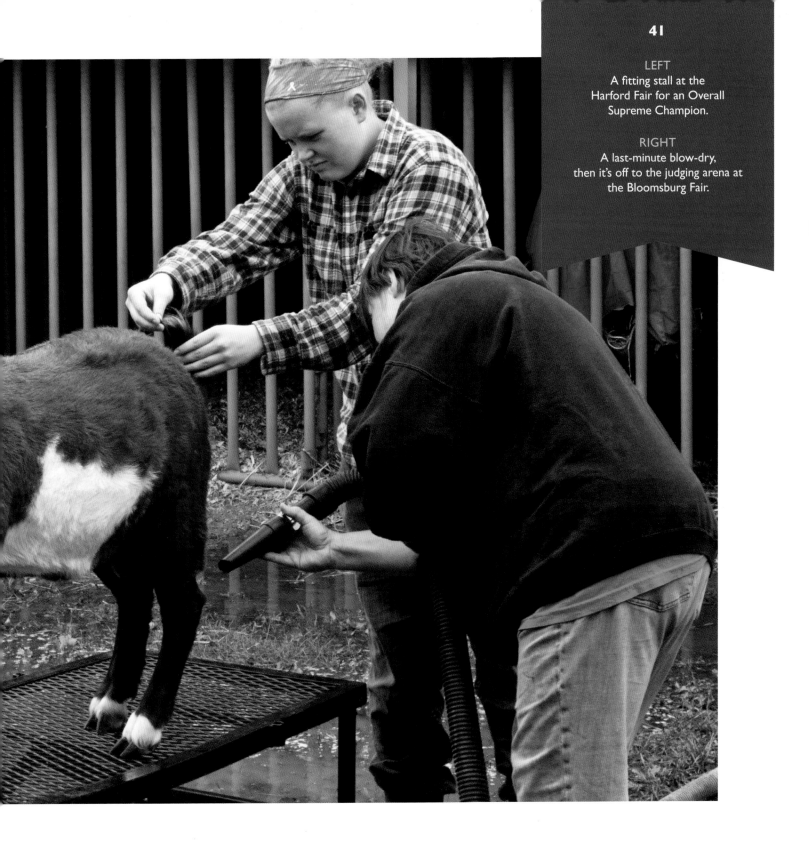

LEFT
A fitting stall at the
Harford Fair for an Overall
Supreme Champion.

RIGHT
A last-minute blow-dry,
then it's off to the judging arena at
the Bloomsburg Fair.

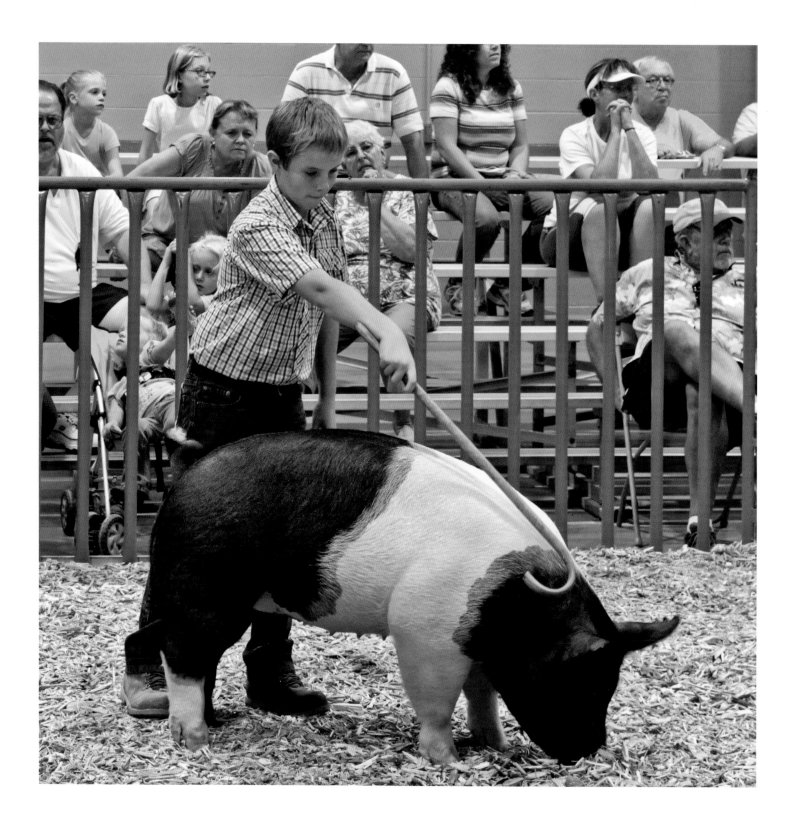

OPPOSITE
Weeks of handling practice
are apparent at the
York Fair's youth Swine Fitting
& Showmanship judging.

RIGHT
A close bond is seen between
mother and calf at the West End
Fair in Gilbert, Pennsylvania.

BELOW
A tender moment between friends
at the Centre County Grange Fair
in Centre Hall, Pennsylvania.

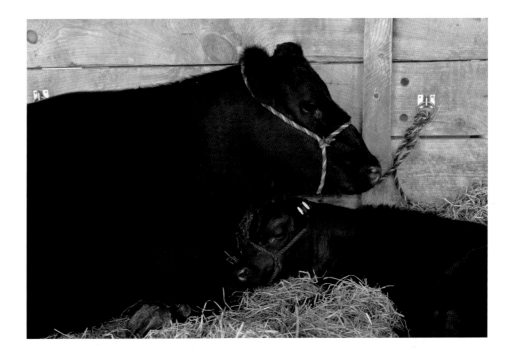

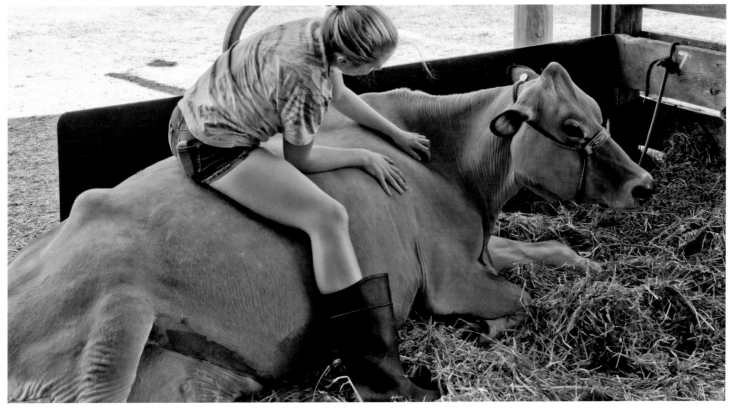

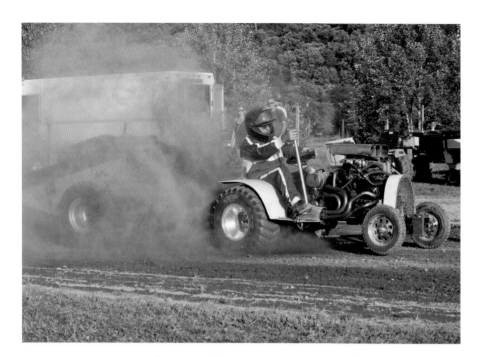

LEFT
Souped-up machines make dust fly
during the Carbon County Fair garden
tractor pull competition.

BELOW
A 1960s-era Farmall 806 tractor
digs in at the tractor pull competition
at the Berks County Fair.

OPPOSITE
David Darwin—One Man Side Show
thrills Lebanon Area Fair visitors.

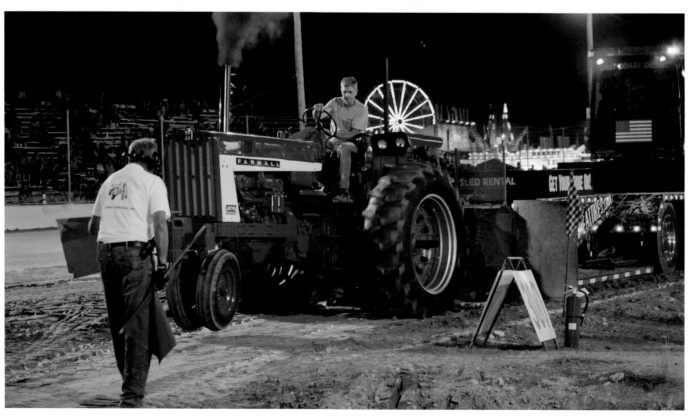

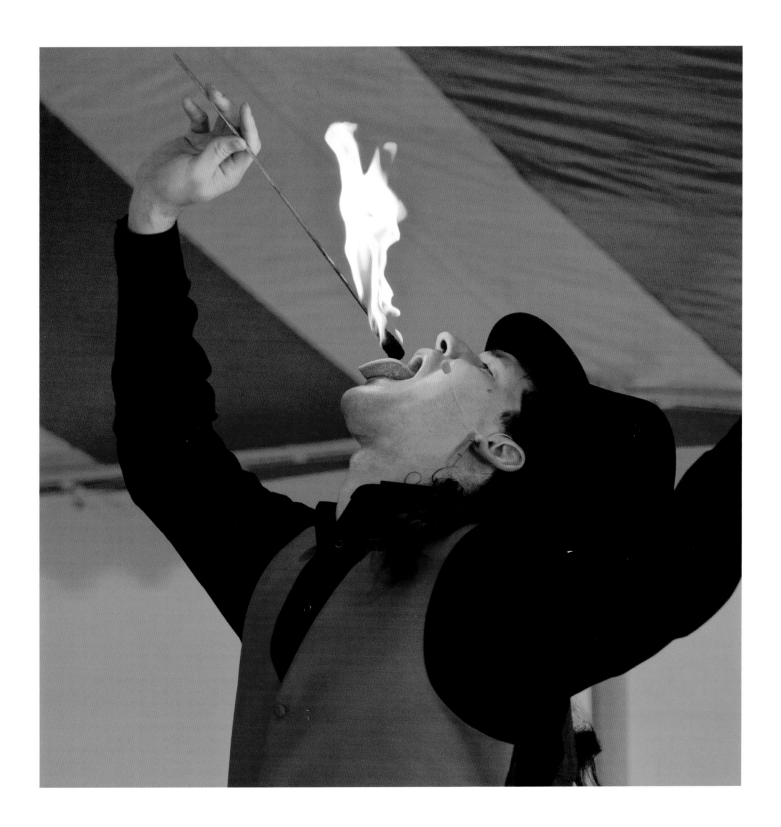

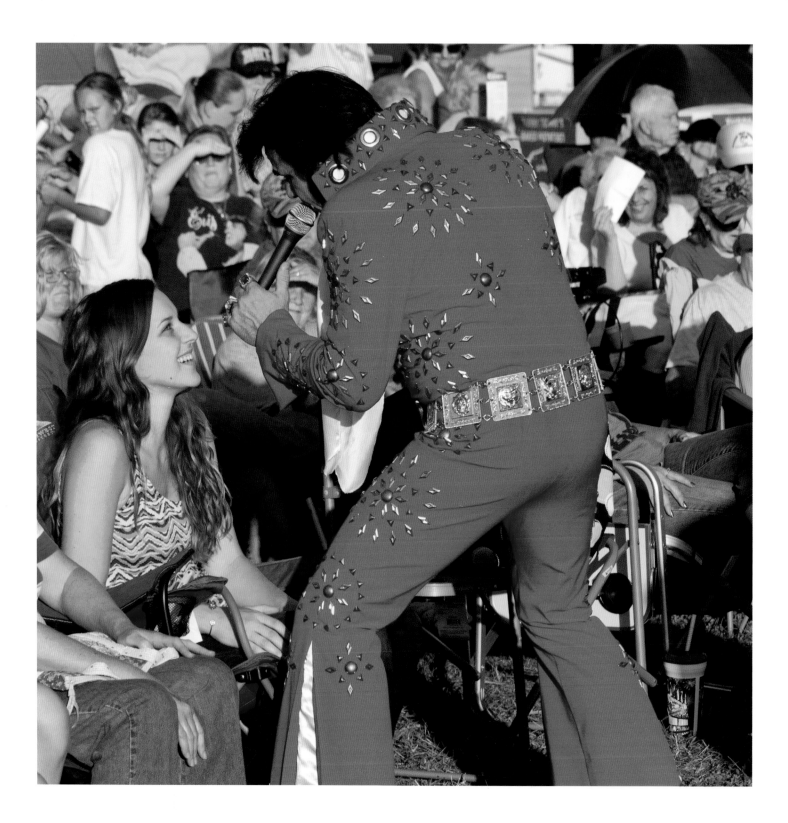

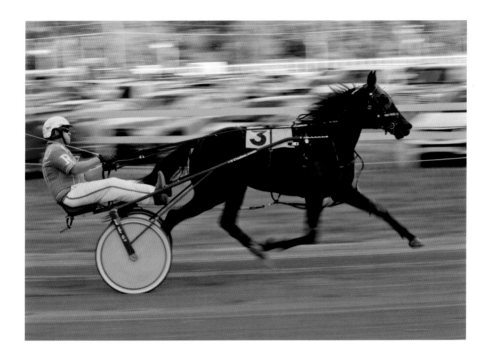

OPPOSITE
Elvis impersonator Andy Svrcek
gives a flawless impersonation of the
King at the Lebanon Area Fair.

LEFT
Harness racing is popular at the
Wayne County Fair, with nationally
known drivers competing for prizes
worth thousands of dollars.

BELOW
Toodles the Clown entertains young
fairgoers at the Wayne County Fair.

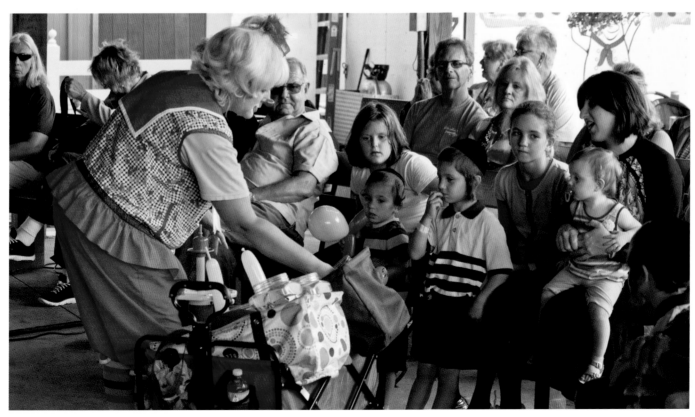

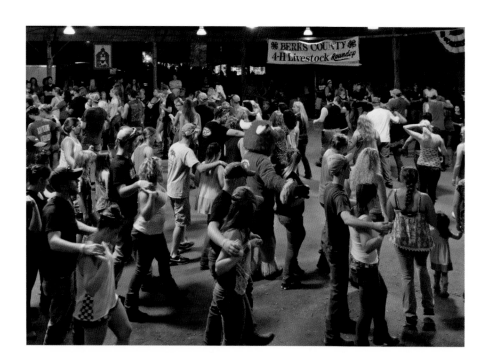

LEFT
The Kutztown Fair
mascot joins the partner dance.

BELOW
The Walker Boys from Tennessee,
and their sister Kendra, perform for
the afternoon crowd at the
West End Fair.

OPPOSITE
Bruno's Royal Bengal Tigers
thrill the crowd at the West End Fair.

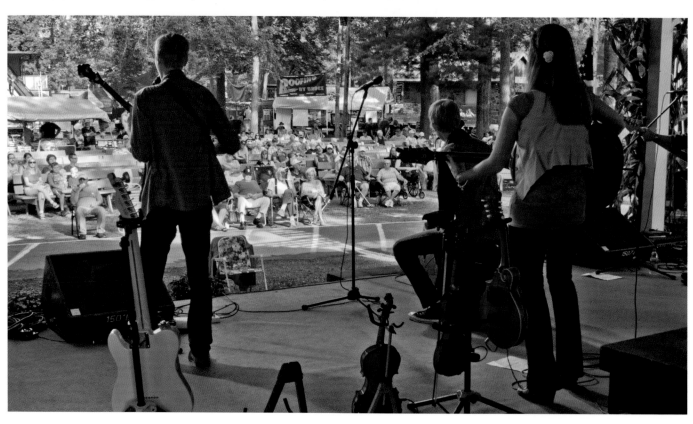

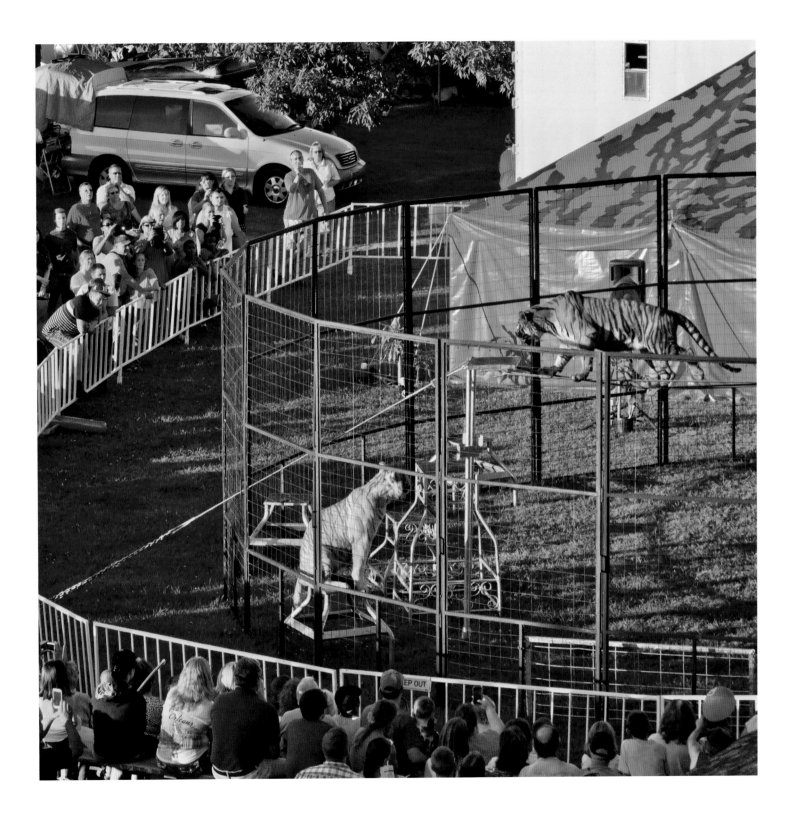

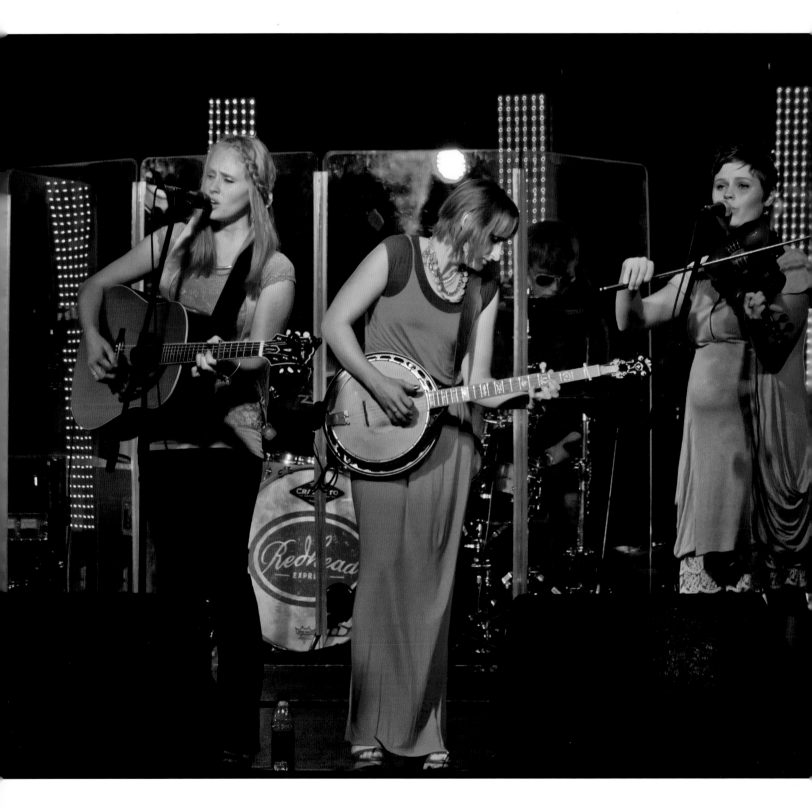

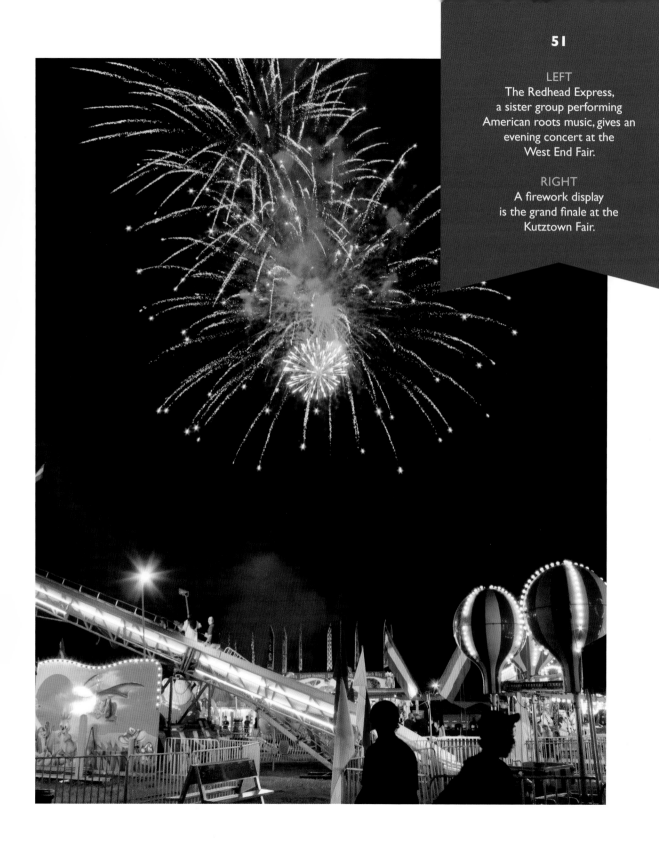

LEFT
The Redhead Express,
a sister group performing
American roots music, gives an
evening concert at the
West End Fair.

RIGHT
A firework display
is the grand finale at the
Kutztown Fair.

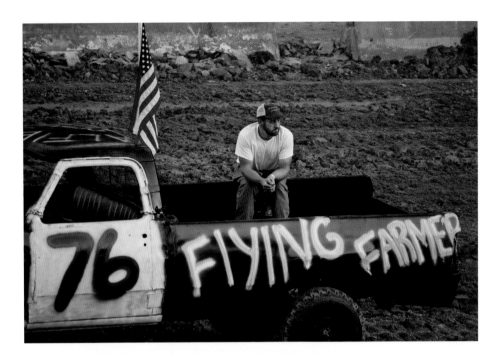

LEFT
The "Flying Farmer" waits for the "Star-Spangled Banner" to begin, signaling the start of the West End Fair demolition derby.

BELOW
The roar of the engine, spinning wheels, and flying dust add to the excitement of the Greene Dreher Sterling Fair's diesel truck pull competition.

OPPOSITE
It's one heck of a free-for-all at the West End Fair's demolition derby. The last drivable car wins.

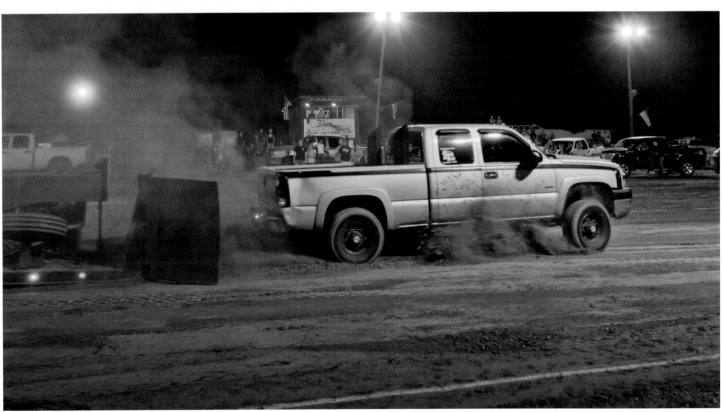

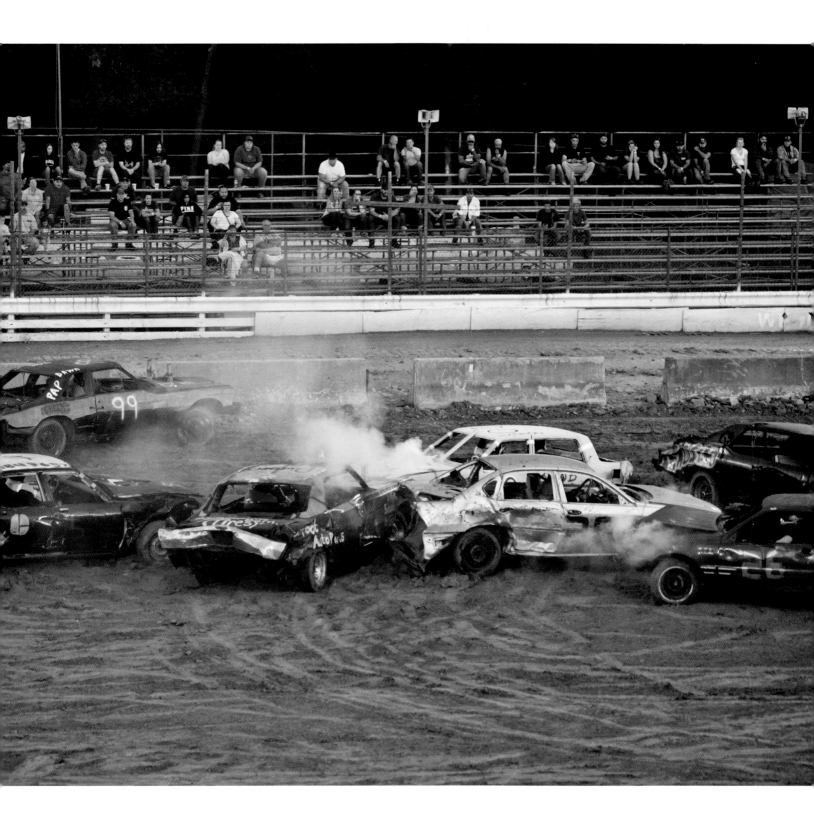

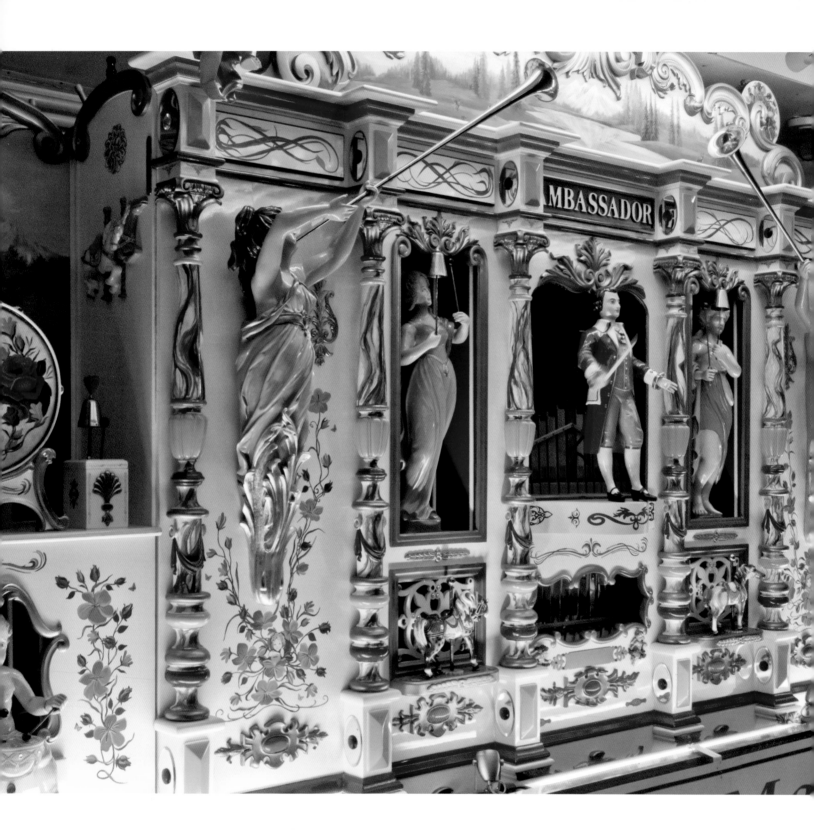

55

OPPOSITE
The Grand Master, the largest automatic musical concert band organ traveling the United States, stops at the West End Fair. The organ plays more than 3,000 tunes as the carved figurines move to the music.

RIGHT
It's polka time at the Allentown Fair!

BELOW
The spectacular draft horse show and competition is one of the highlights of the Centre County Grange Fair.

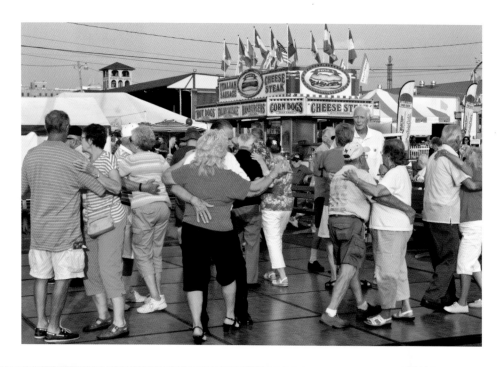

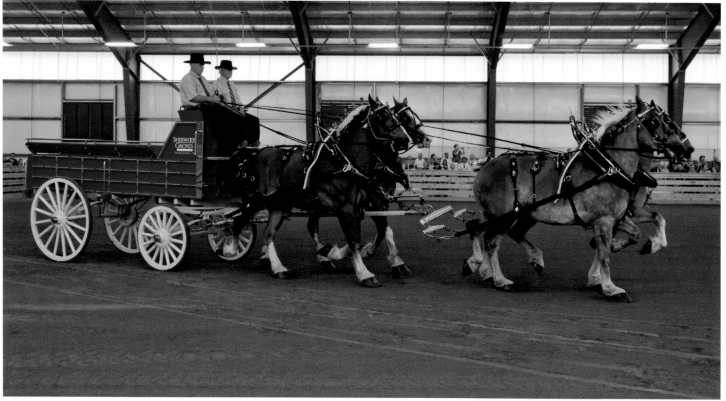

56

LEFT
High-speed juggling by
Shane Hansen dazzles spectators at
the Allentown Fair.

CENTER
The pig race is always a popular event
at the Allentown Fair.

RIGHT
High above the crowd at the Centre
County Grange Fair, the Circus Una
Motorcycle High-Wire Thrill Show
includes breathtaking stunts.

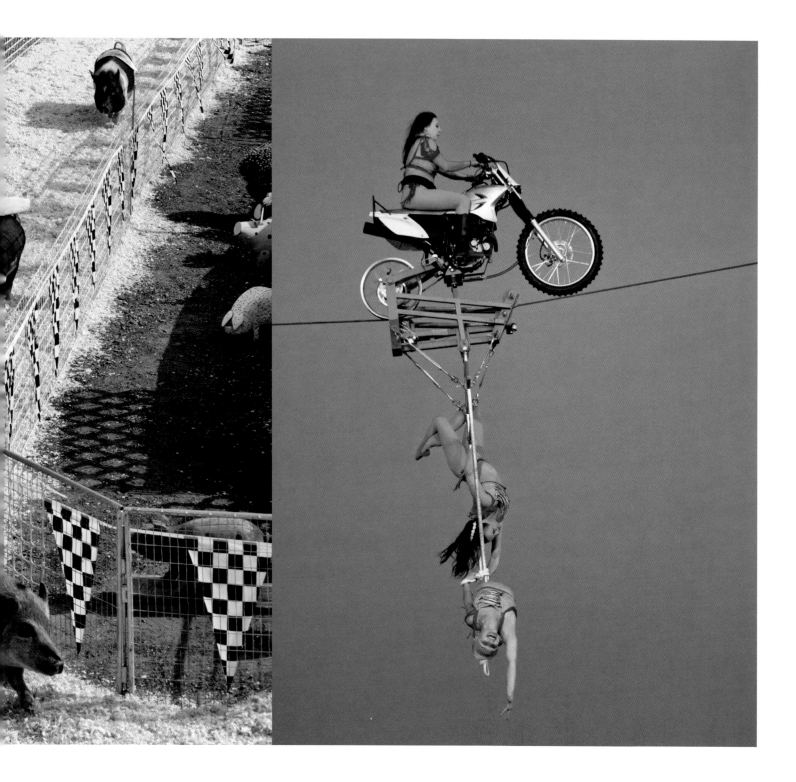

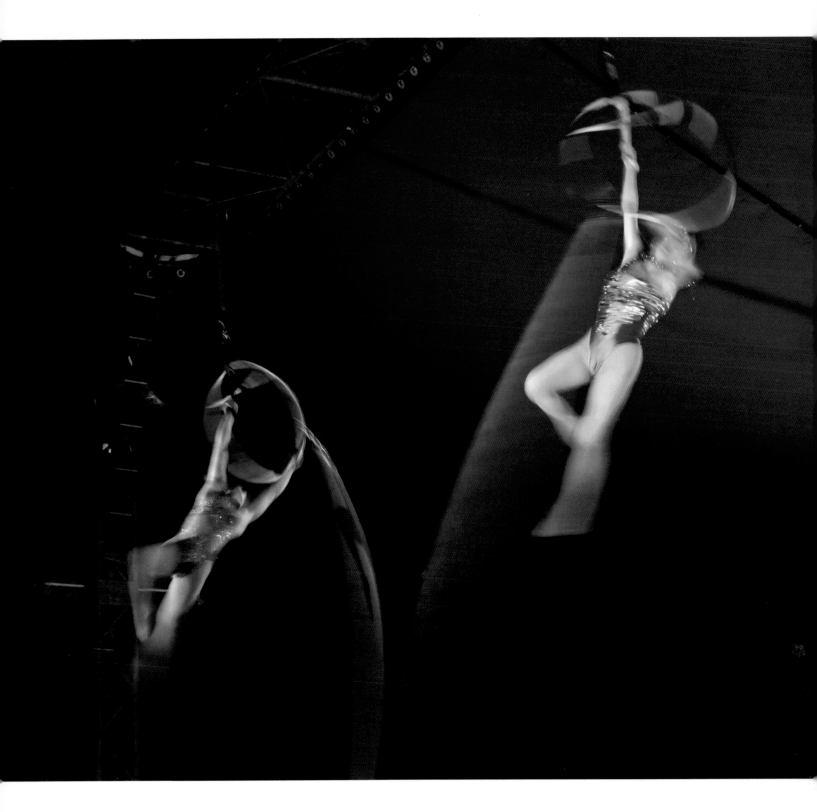

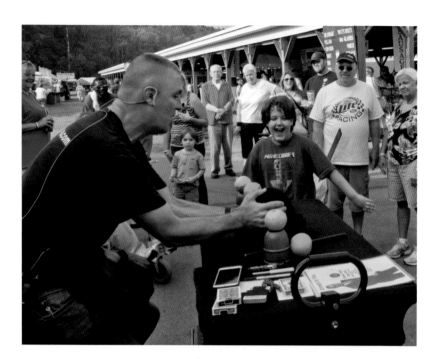

OPPOSITE
Performers from the Royal
Hanneford Circus spin under the
big top at the York Fair.

LEFT
Magician Matt Episcopo
"Magic Matt" entertains young and
old at the Greene Dreher Sterling
Fair in Wayne County.

BELOW
Tumblers from the Royal
Hanneford Circus amaze the York
Fair audience with their precision.
balance, and timing.

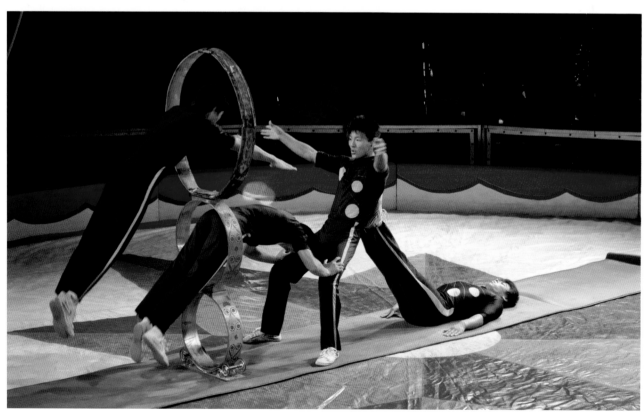

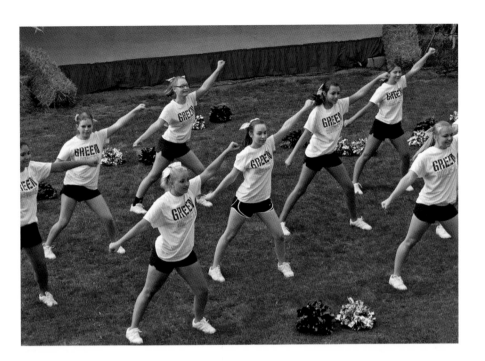

LEFT
The Emmaus High School
Green Hornets cheerleaders
demonstrate their precision at
the Allentown Fair.

BELOW
The Wallenpaupack High School
Marching Band performs
at Wayne County's Greene
Dreher Sterling Fair.

OPPOSITE
Just one of the special moments
at the York Fair.

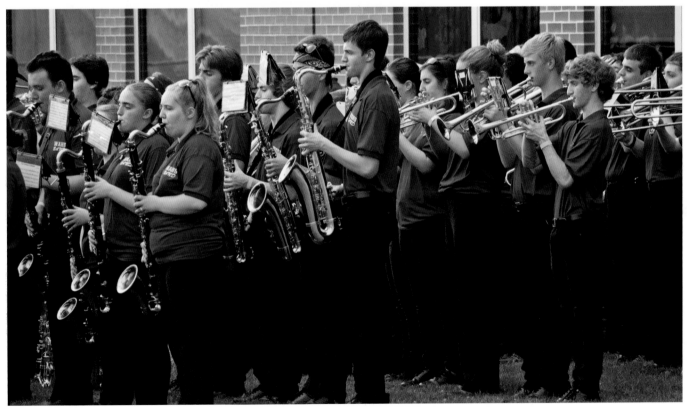

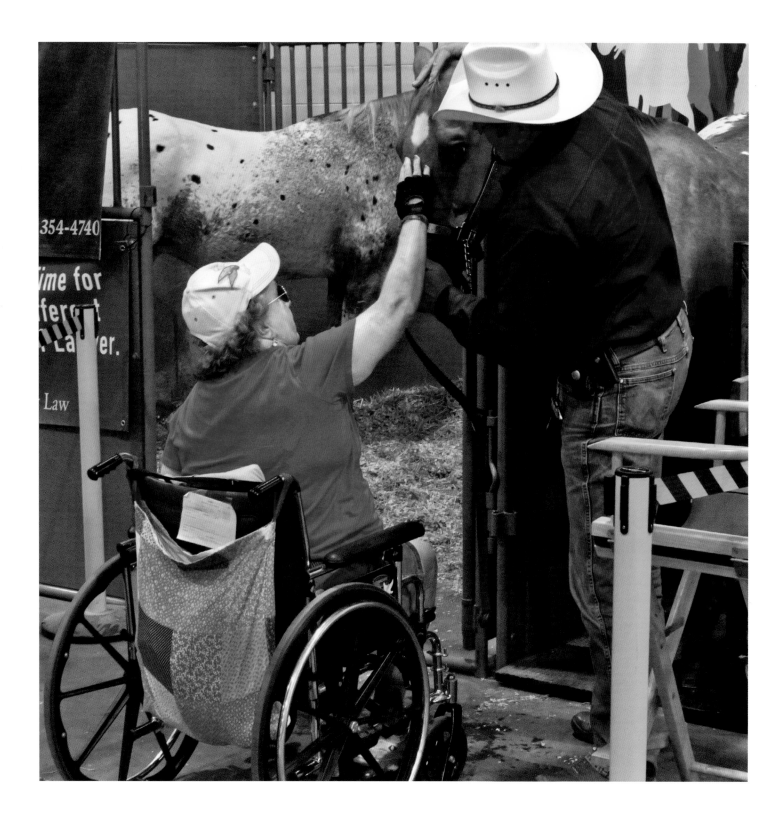

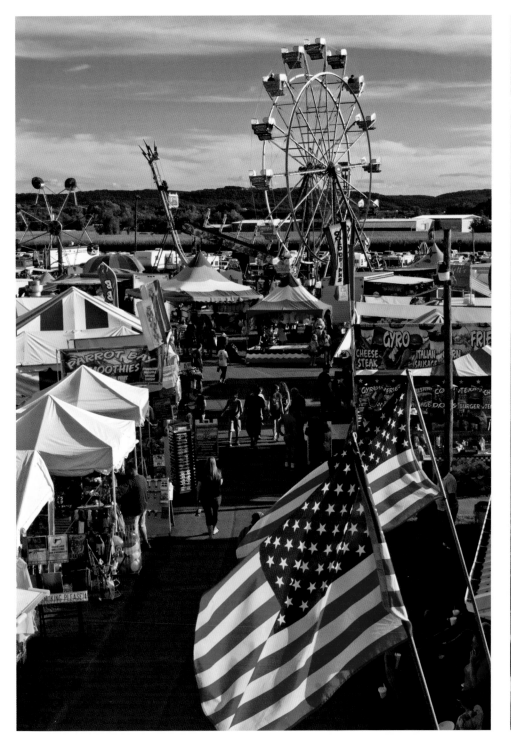

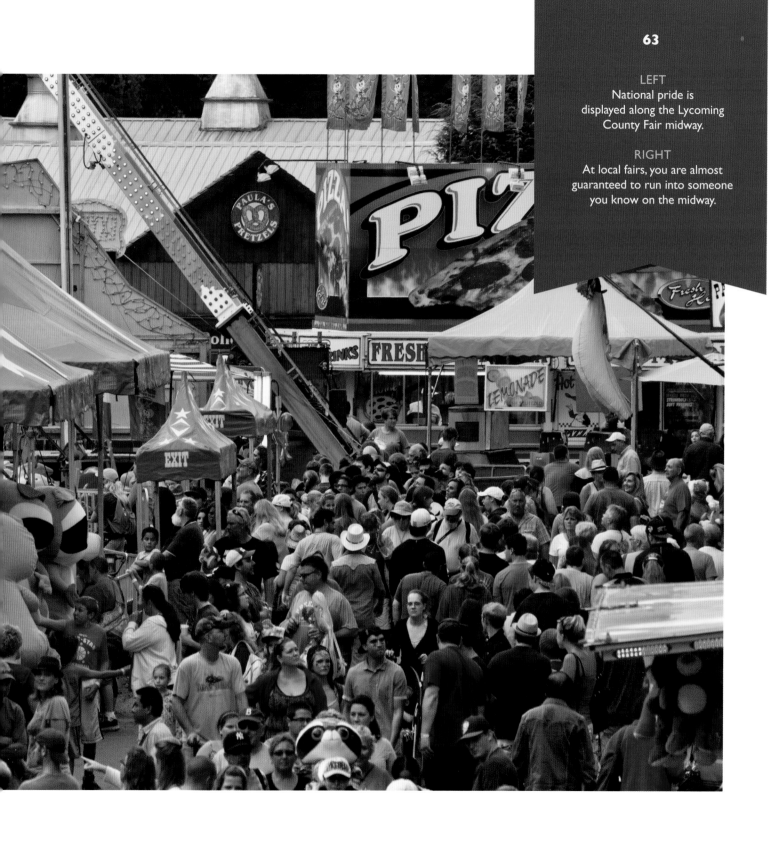

63

LEFT
National pride is displayed along the Lycoming County Fair midway.

RIGHT
At local fairs, you are almost guaranteed to run into someone you know on the midway.

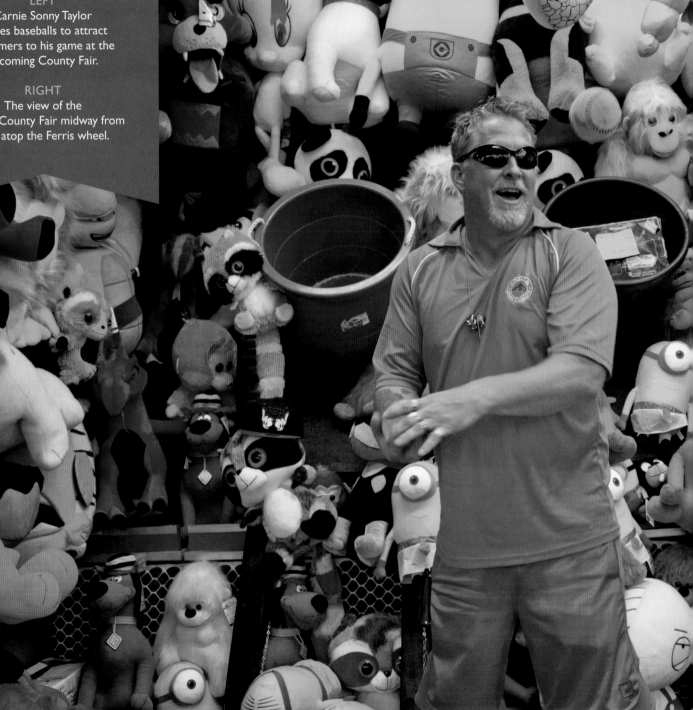

LEFT
Carnie Sonny Taylor
juggles baseballs to attract
customers to his game at the
Lycoming County Fair.

RIGHT
The view of the
Wayne County Fair midway from
high atop the Ferris wheel.

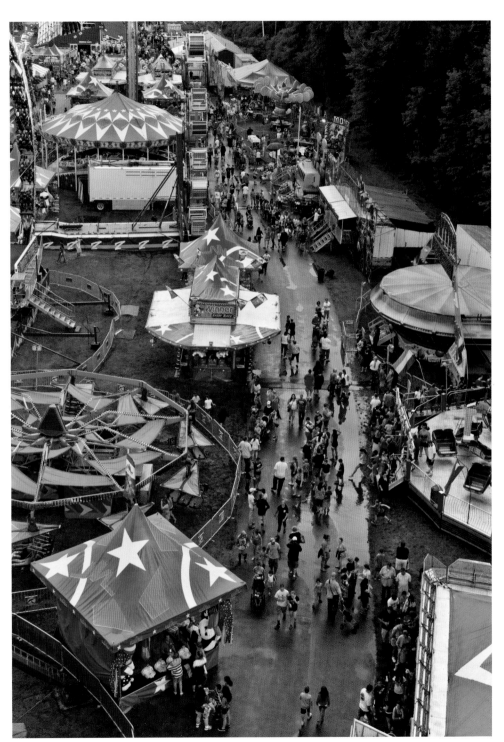

LEFT
A proud winner carries off his prize at the Wayne County Fair.

BELOW
A sharpshooter shows his buddies how it's done at the Kutztown Fair.

OPPOSITE
Stealing a kiss on the midway at the Wayne County Fair.

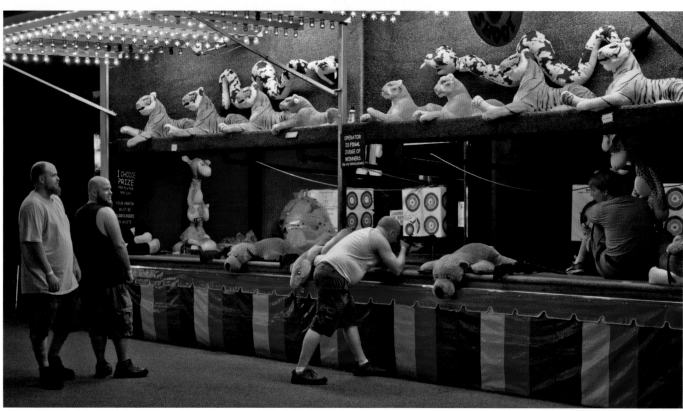

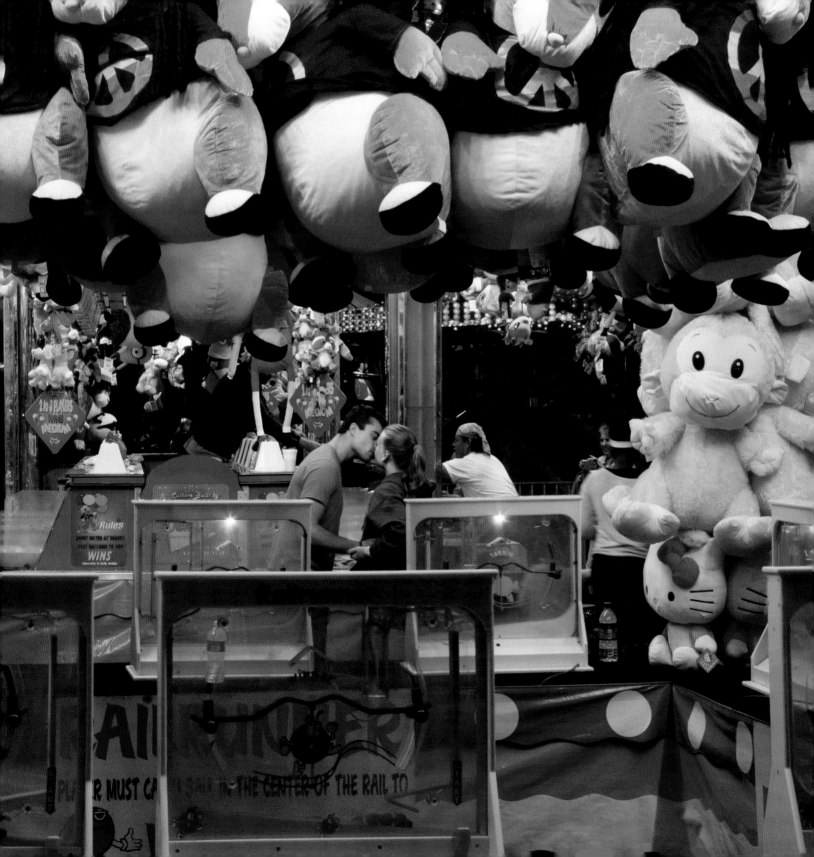

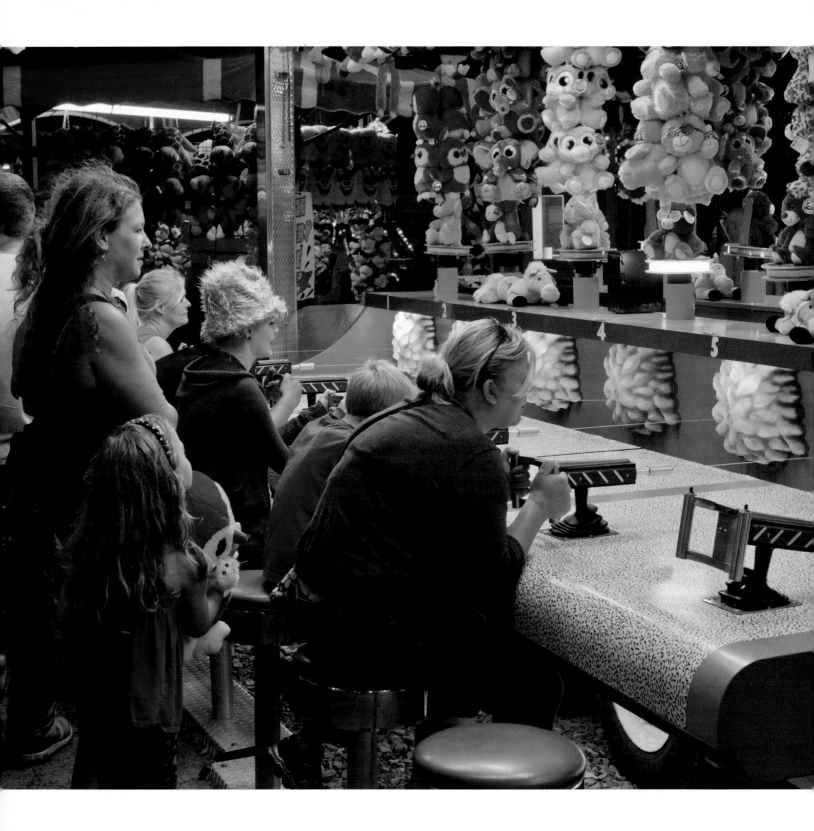

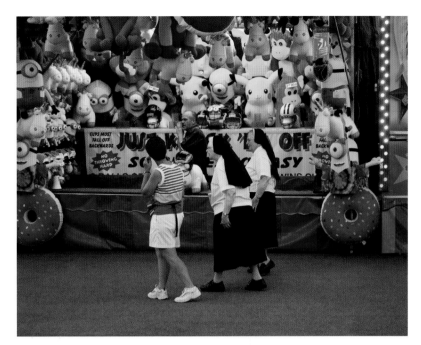

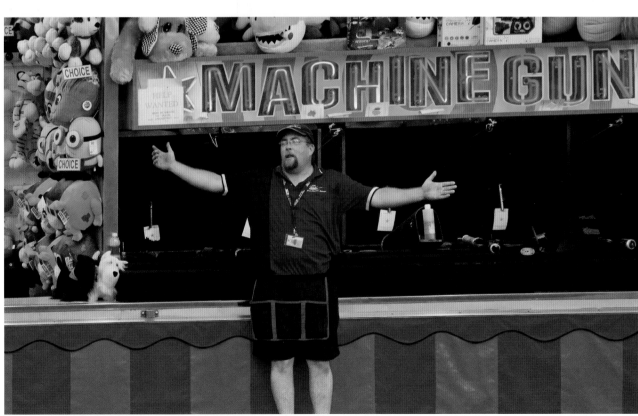

OPPOSITE
Contestants compete to reach the top in the Water Race game at the Harford Fair in New Milford, Pennsylvania.

LEFT
Catholic nuns take time off to stroll the Allentown Fair midway.

BELOW
A game carnie invites people to try their skill at his shooting galley.

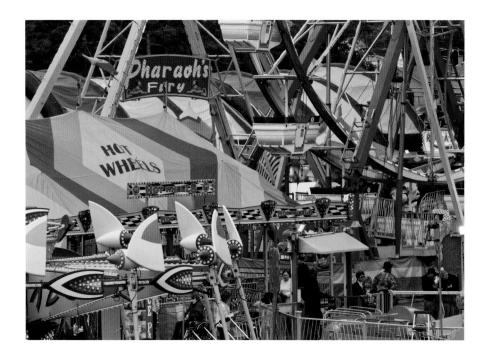

LEFT
The colorful rides on the
Bloomsburg Fair midway.

BELOW
Holding hands and watching
the midway rides at the Greene
Dreher Sterling Fair.

OPPOSITE
A happy face greets visitors
at the Bloomsburg Fair.

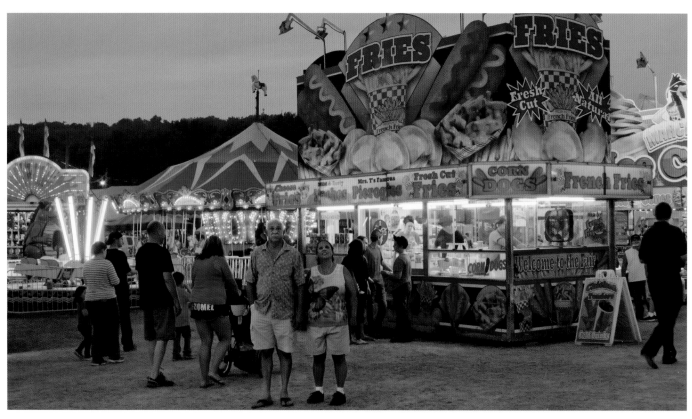

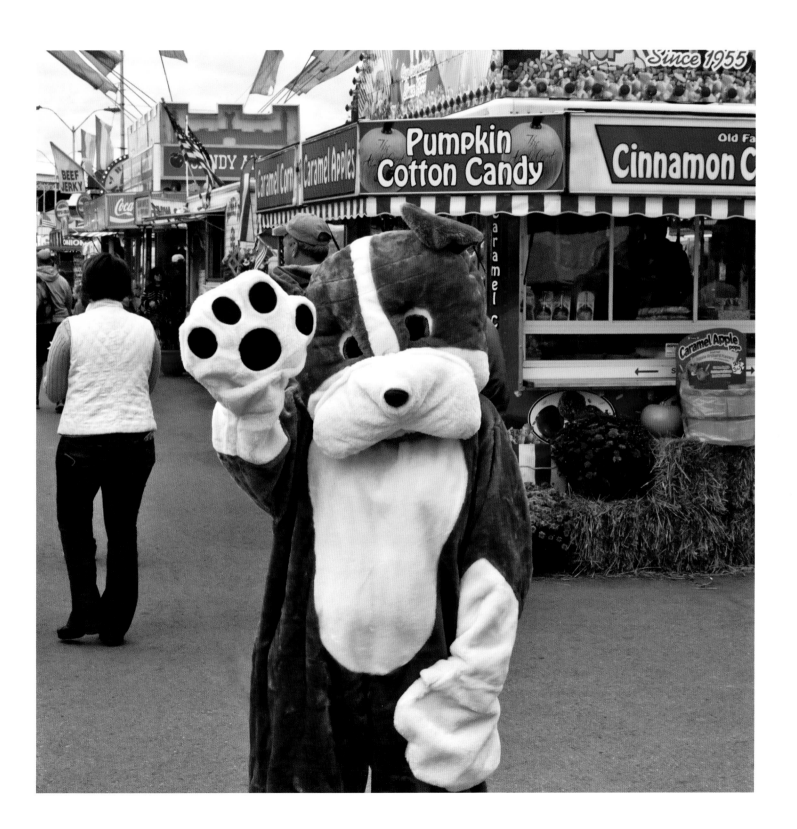

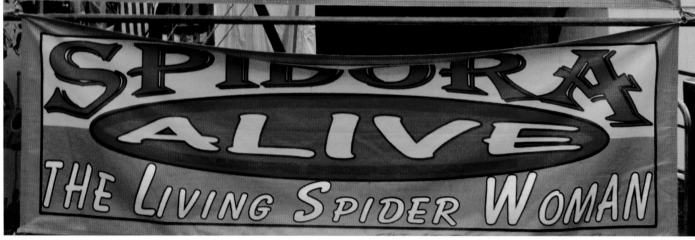

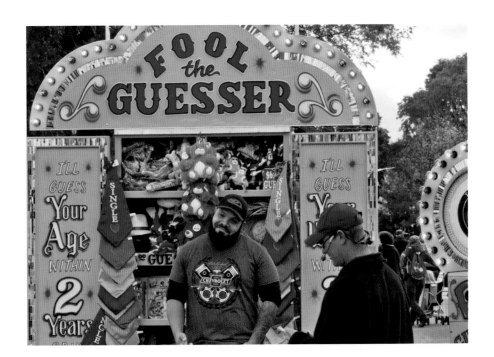

OPPOSITE
It's not every day that you can talk
to a spider woman, but you can at
the Bloomsburg Fair.

LEFT
If you fool the Guesser with your
age and weight, you win a prize at
the Bloomsburg Fair.

BELOW
Curiosity lures fairgoers
to the Living Snake Woman at the
Bloomsburg Fair.

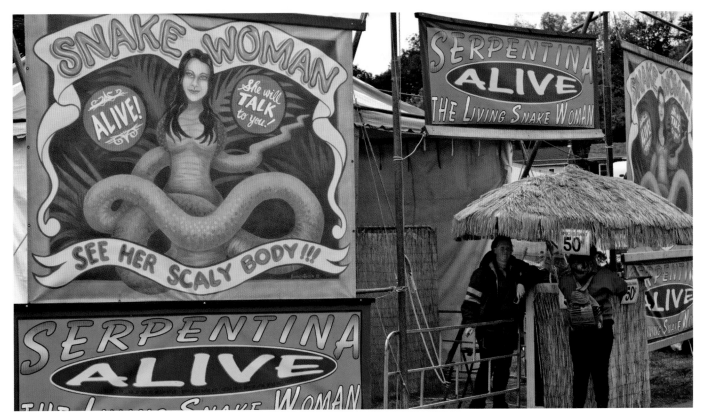

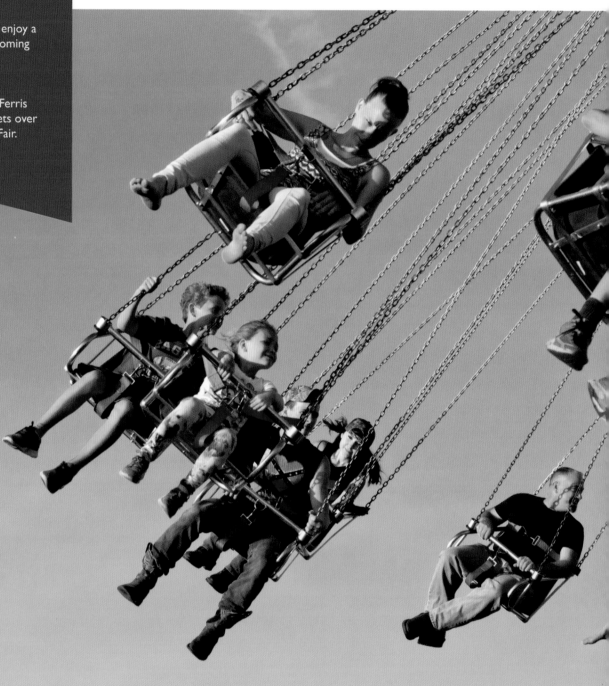

LEFT
Riders on the YoYo Swings enjoy a bird's-eye view of the Lycoming County Fair.

RIGHT
The evening sky and the Ferris wheel light up as the sun sets over the Lycoming County Fair.

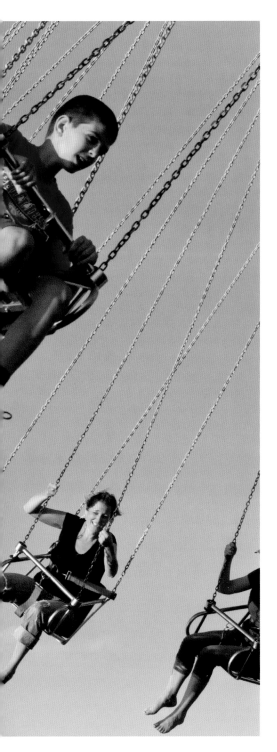
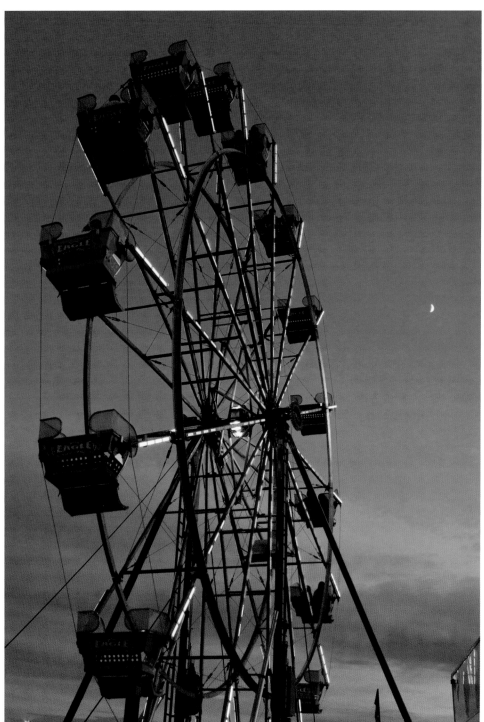

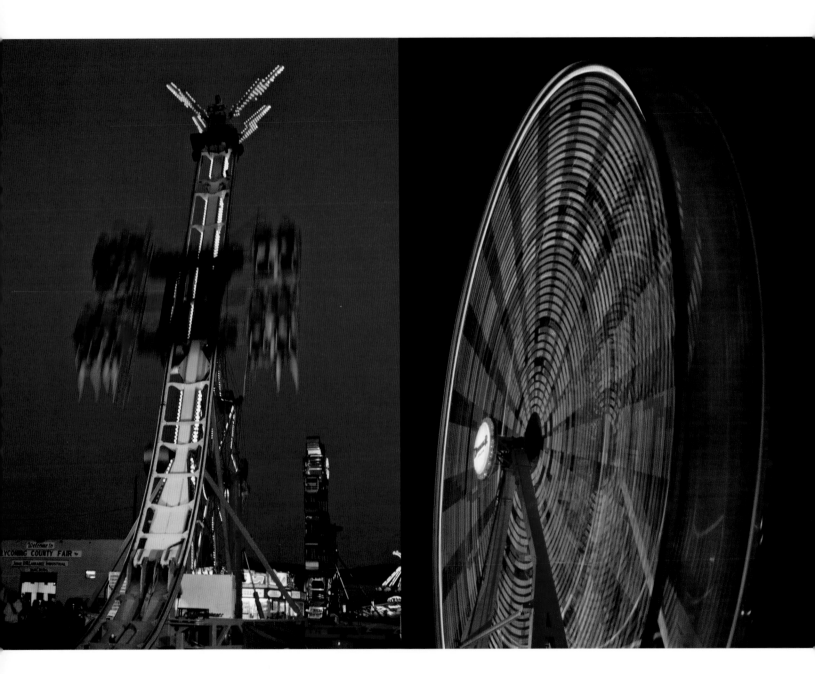

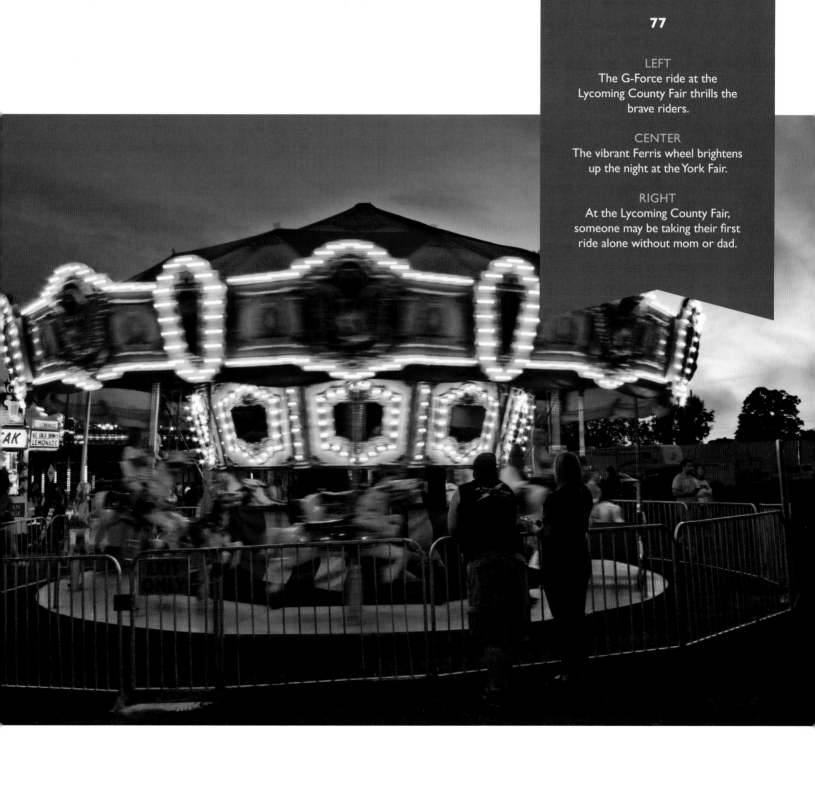

LEFT
The G-Force ride at the Lycoming County Fair thrills the brave riders.

CENTER
The vibrant Ferris wheel brightens up the night at the York Fair.

RIGHT
At the Lycoming County Fair, someone may be taking their first ride alone without mom or dad.

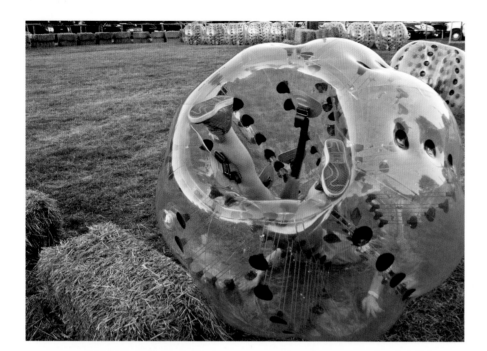

LEFT
Knockerballs, which give the
sensation of defying gravity, are as
much fun for spectators as they are
for the participants at the
Carbon County Fair.

BELOW
The Quasar spins riders above
the ground, while YoYo riders
in the background swing high above
the evening midway at the
Lycoming County Fair.

OPPOSITE
Young thrill riders enjoy the Jumpin'
Star ride at the Reading Fair.

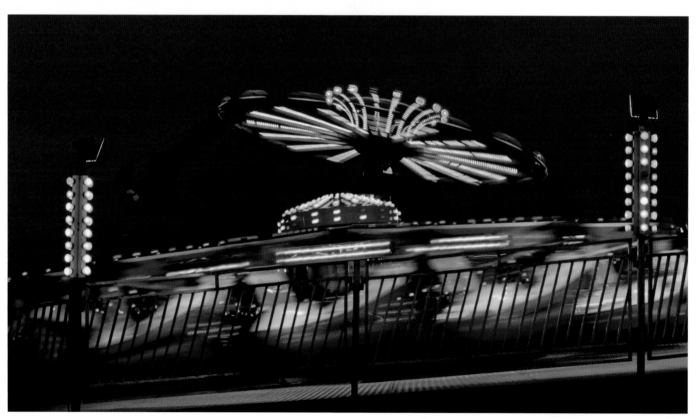

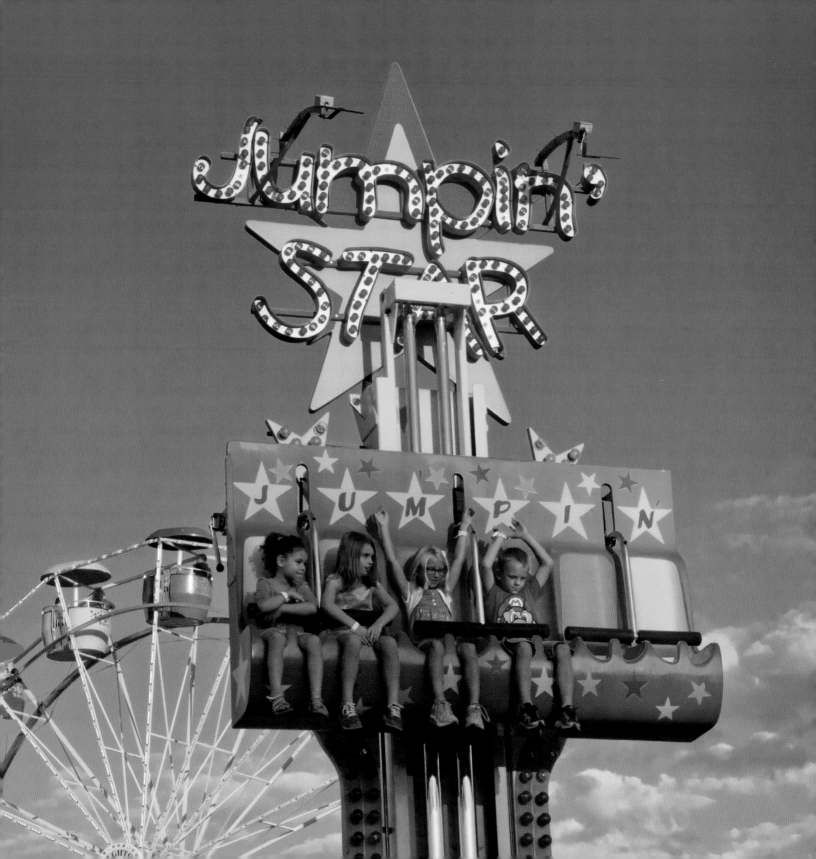

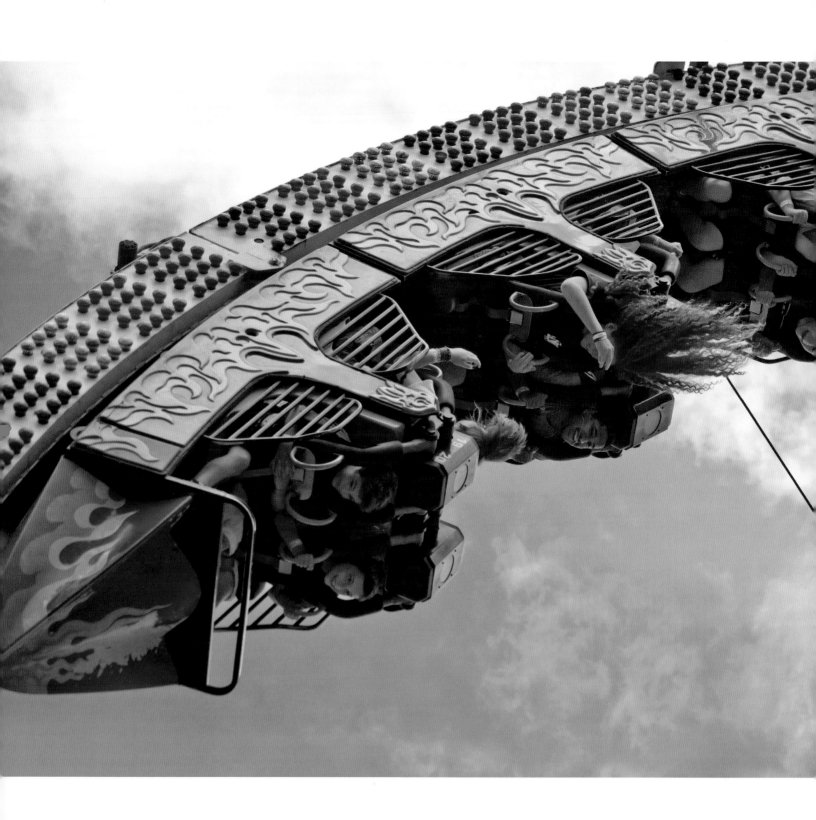

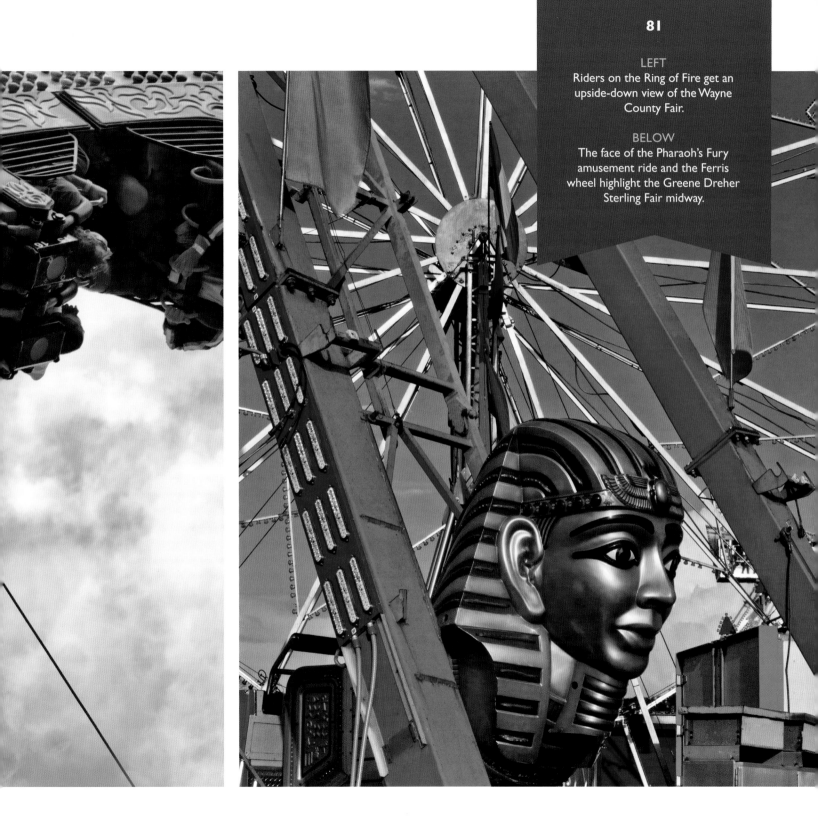

LEFT
Riders on the Ring of Fire get an upside-down view of the Wayne County Fair.

BELOW
The face of the Pharaoh's Fury amusement ride and the Ferris wheel highlight the Greene Dreher Sterling Fair midway.

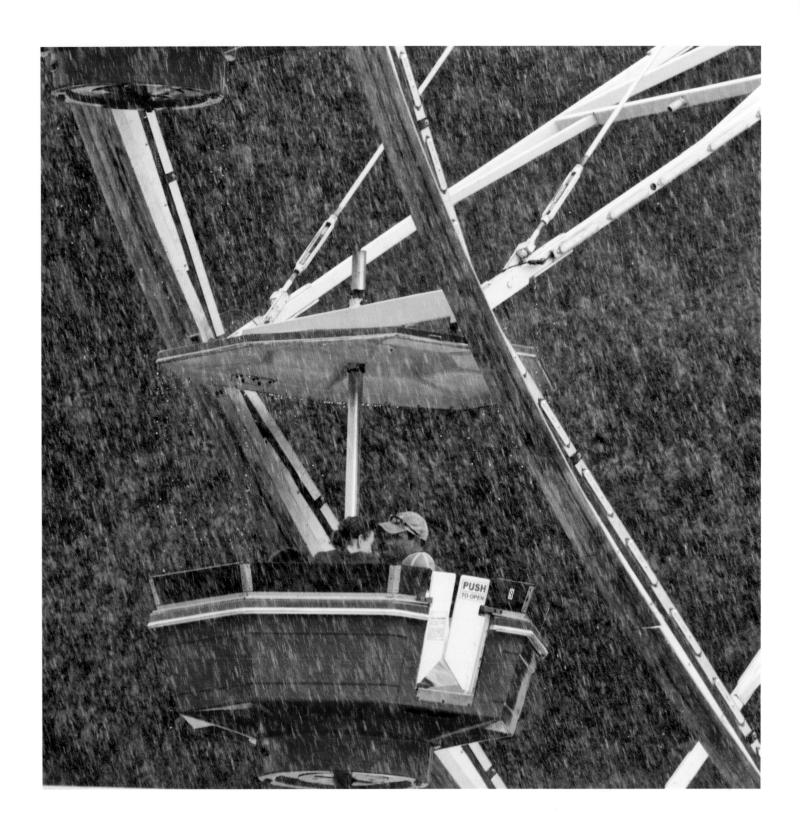

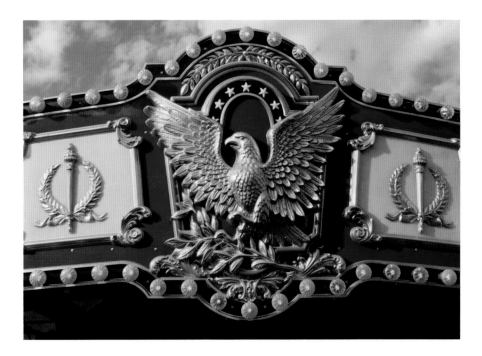

OPPOSITE
Riders get caught on the Wayne County Fair's Ferris wheel in a sudden summer downpour.

LEFT
A beautifully carved eagle spreads its wings atop the carousel like an imperial coat of arms at the Harford Fair.

BELOW
The carousel horse at the Harford Fair is a work of art.

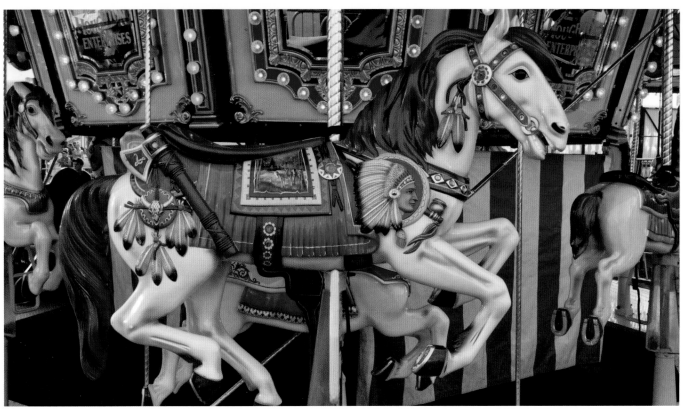

LEFT
At the York Fair, the Magic Maze funhouse's trick mirrors and mazes entertain young and old.

BELOW
The Hurricane amusement ride lifts riders up and down in a small cockpit while rotating at a high speed.

OPPOSITE
The Zipper ride at the Greene Dreher Sterling Fair in Wayne County guarantees a thrill.

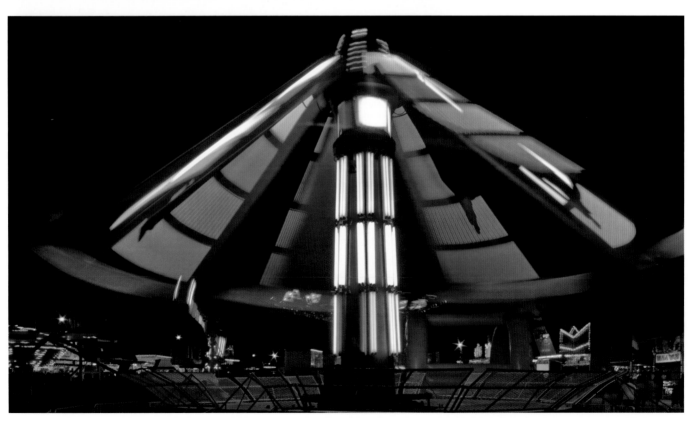

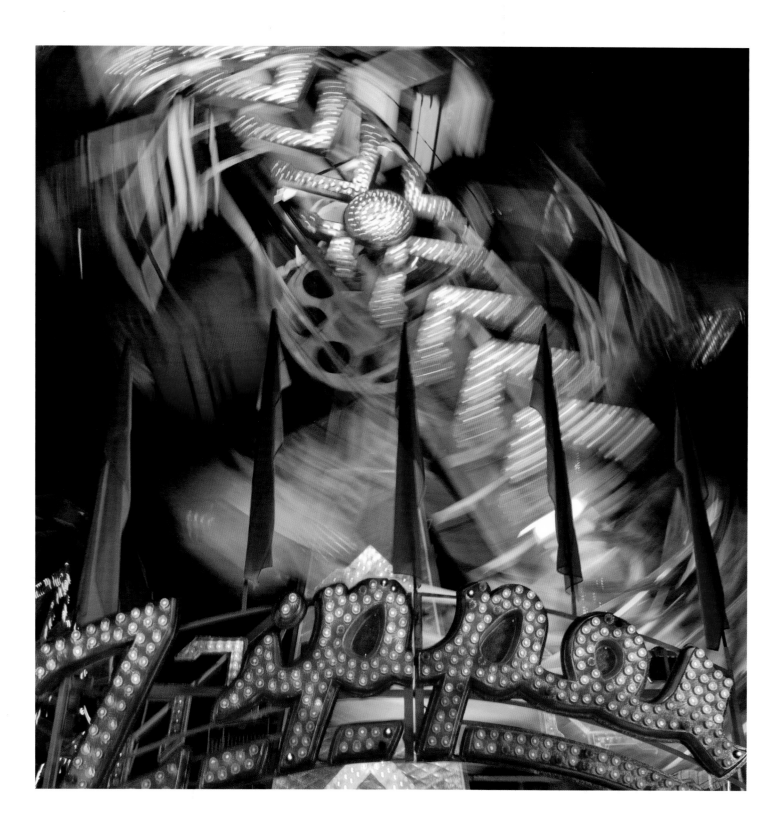

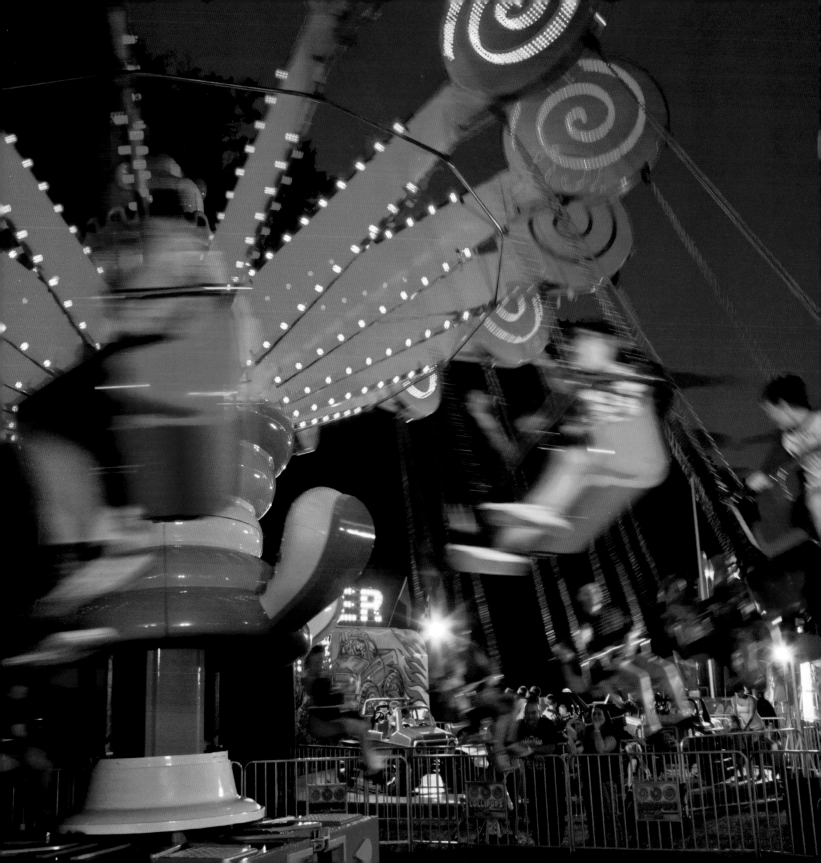

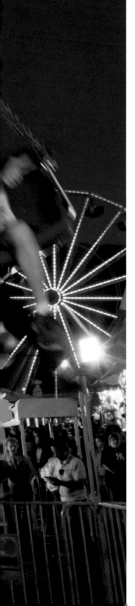

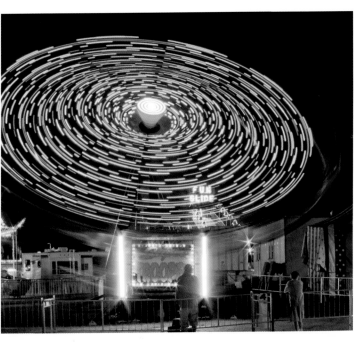

OPPOSITE
The Lollipop Swings introduce kids to the more daring amusement park rides that will follow in a few years.

LEFT
The rotating Super Trooper spins riders at the Centre County Grange Fair.

BELOW
At the Harford Fair, the Round Up and Gondola Wheel rides keep riders spinning.

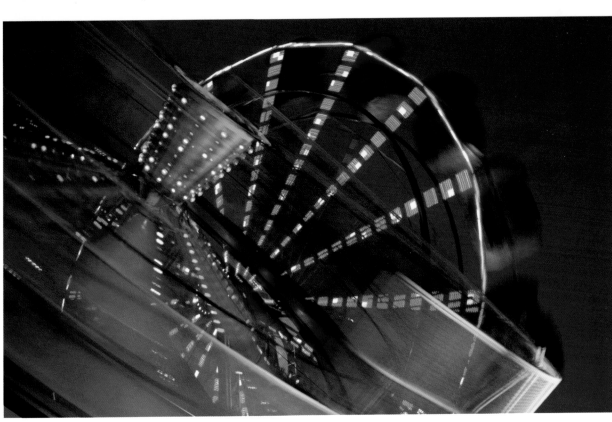

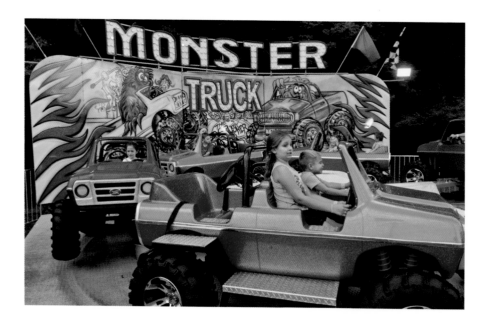

LEFT
A daring ride on the Monster Trucks at the Wayne County Fair.

BELOW
What young man can resist the temptation to ride the mechanical bull, also known as a rodeo bull, to impress his friends?

OPPOSITE
At the Allentown Fair, upside-down riders brave the Khaos.

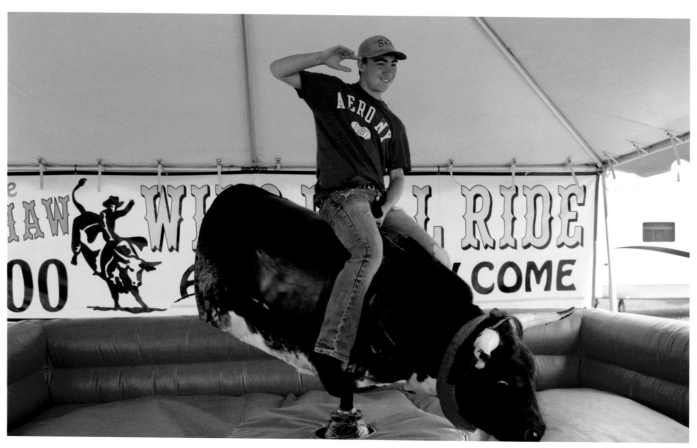

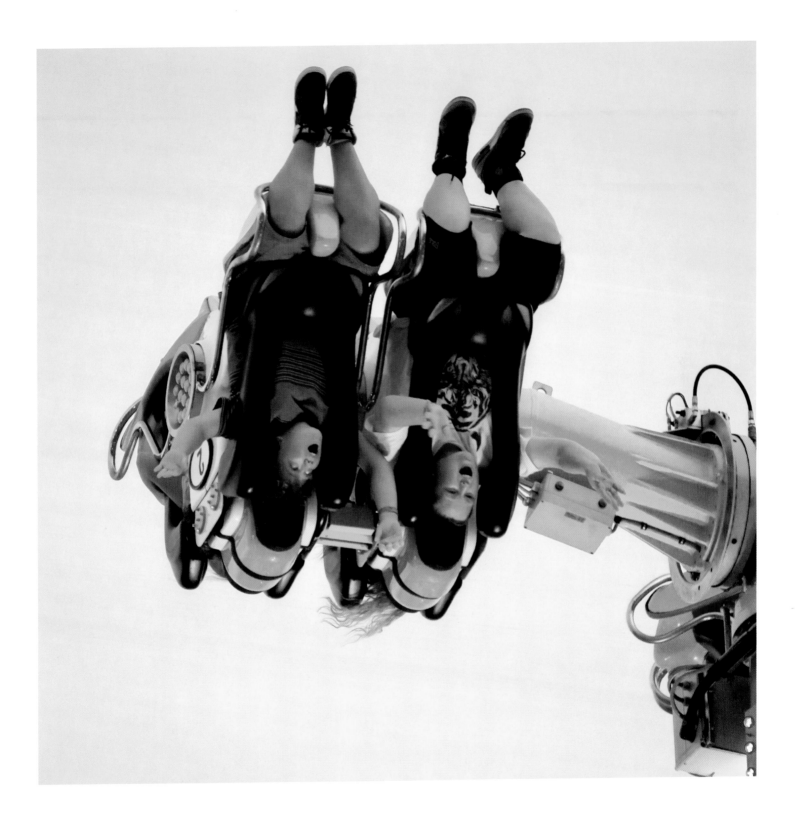

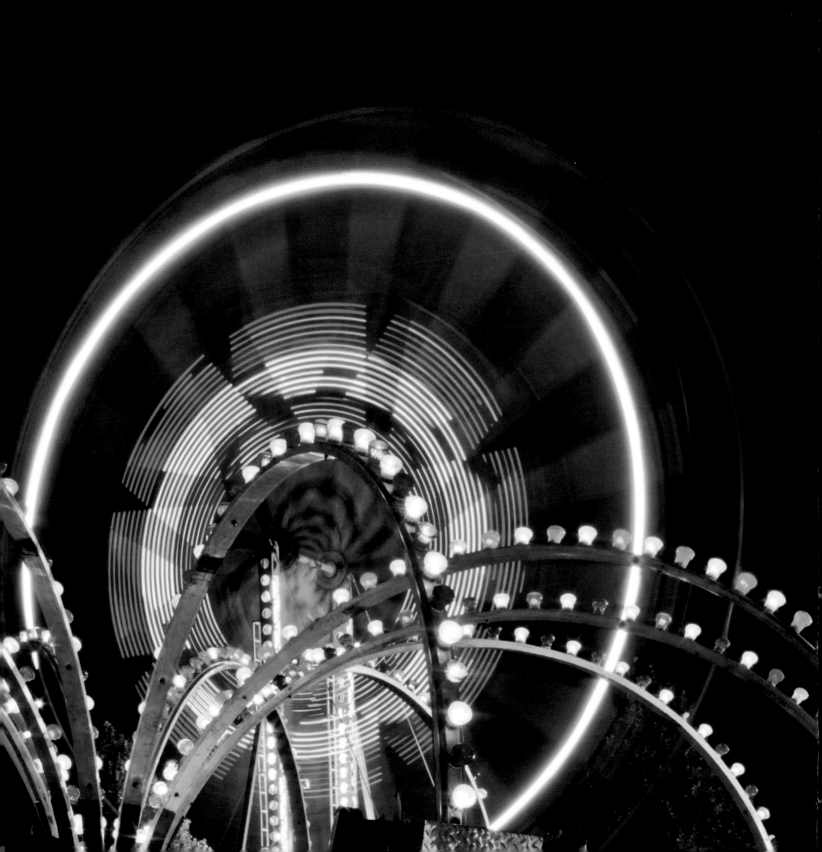

OPPOSITE
The Aladdin and Ferris wheel light up the night sky at the Centre County Grange Fair. Some might even see the illusion of a human face in the moving lights.

LEFT
The Zero Gravity ride spins against the night sky at the York Fair.

BELOW
The Hi Roller thrill ride in motion at the York Fair.

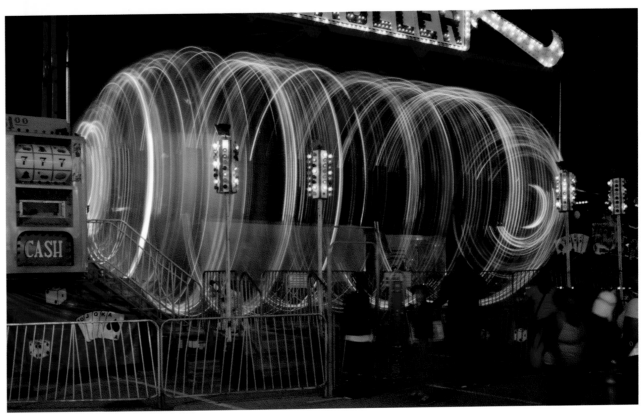

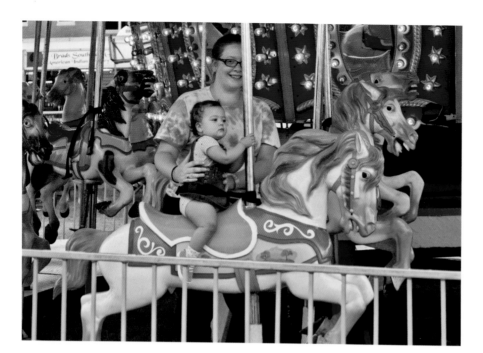

LEFT
First time in the saddle at the Greene Dreher Sterling Fair.

BELOW
Everyone seems to have a different reaction to the Typhoon at the Greene Dreher Sterling Fair.

OPPOSITE LEFT
The ninety-foot Super Slide at the Greene Dreher Sterling Fair is no backyard sliding board.

OPPOSITE RIGHT
At the Greene Dreher Sterling Fair, Super Shot riders near the top of the 140-foot drop.

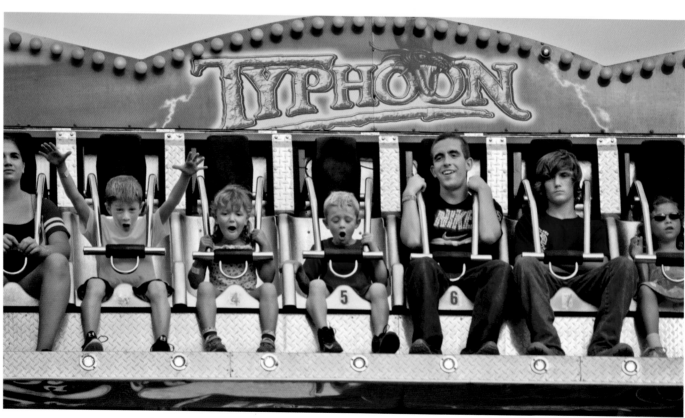

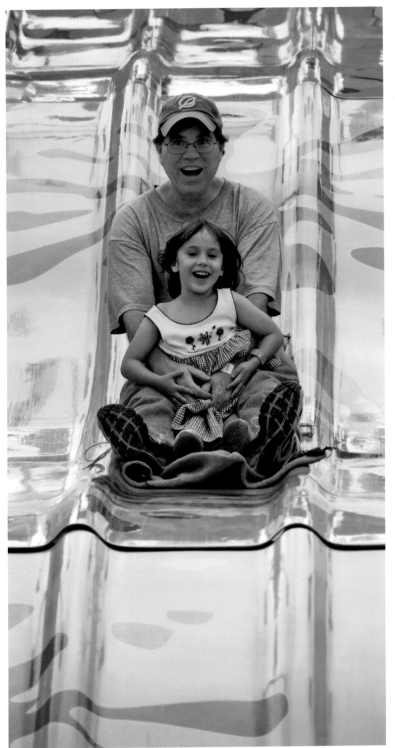
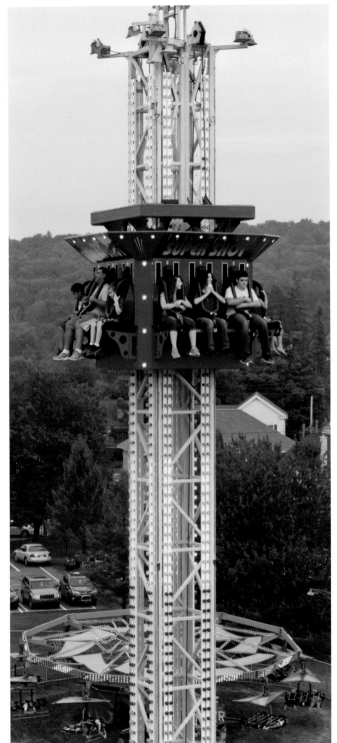

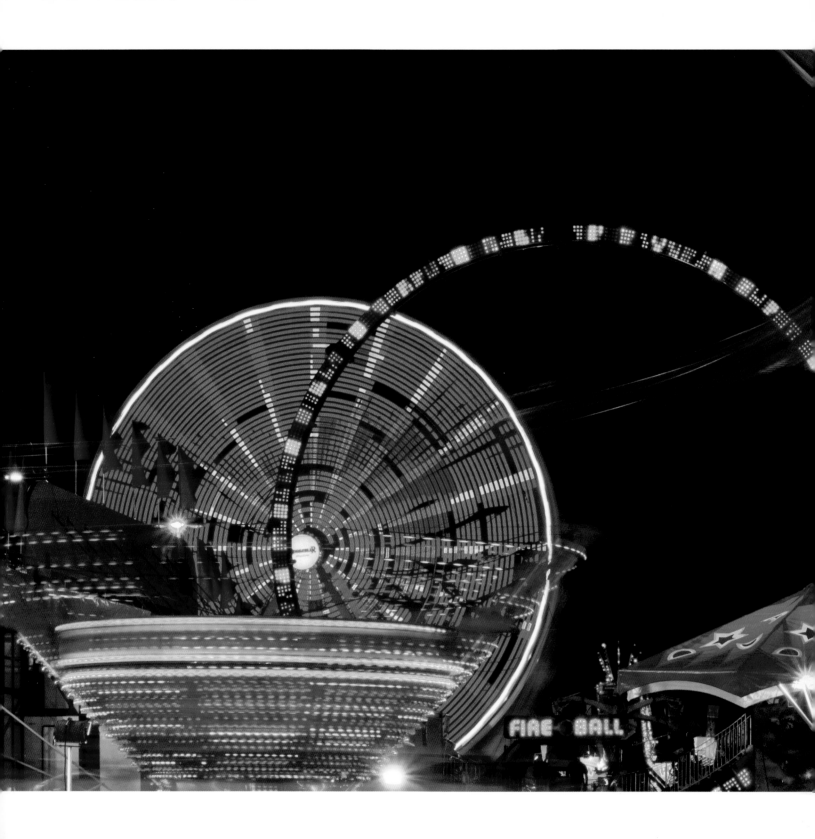

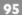
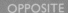

OPPOSITE
Colorful amusement ride lights at the York Fair.

LEFT
Children on the classic Tea Cups at the York Fair can choose how fast to spin the cups.

BELOW
The Hang Ten thrill ride spins riders at the York Fair on a warm summer night.

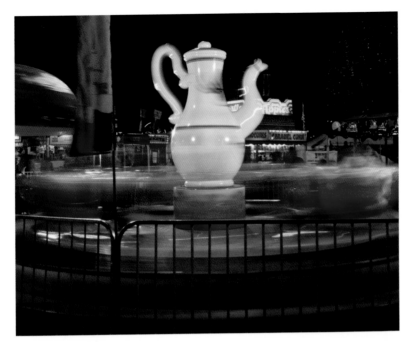

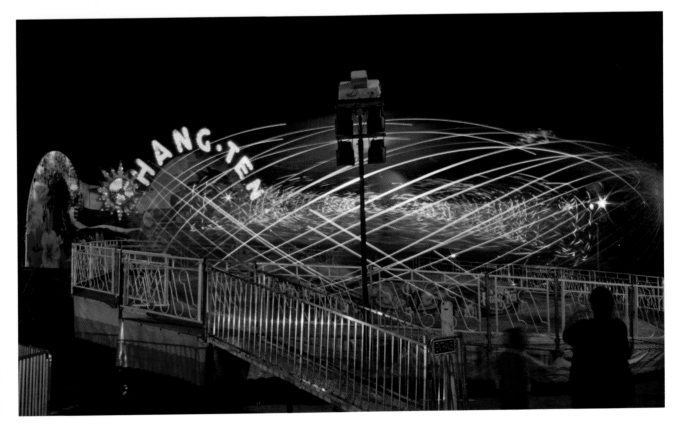

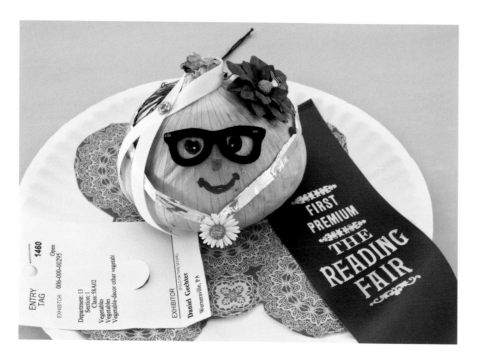

LEFT
A smiling onion wins first place in the vegetable-décor competition at the Reading Fair.

BELOW
There is no such thing as a simple potato in the judging at the Centre Grange Fair.

OPPOSITE LEFT
The goal is always the blue ribbon.

OPPOSITE RIGHT
A 4-H entry of tiger-pattern red tomatoes at the Centre County Grange Fair.

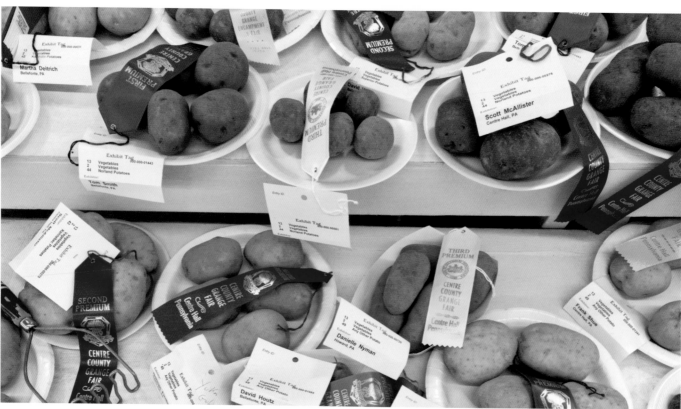

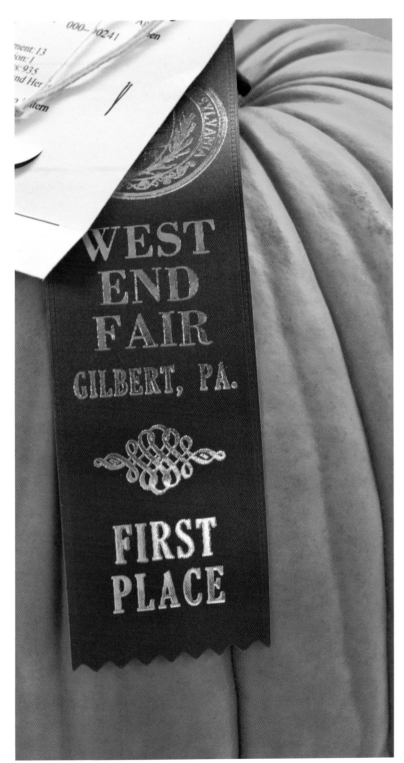

WEST END FAIR
GILBERT, PA.
FIRST PLACE

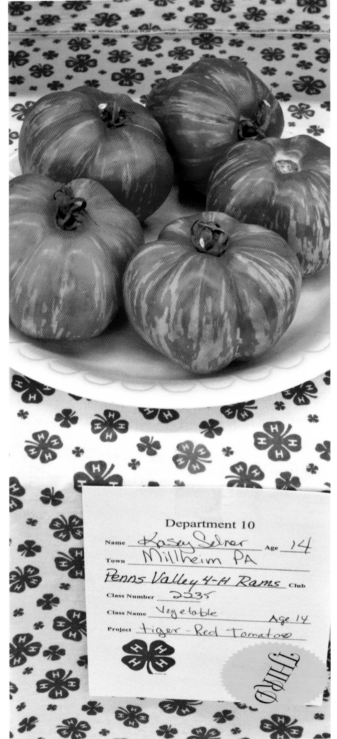

Department 10
Name _Kasey Selner_ Age _14_
Town _Millheim PA_
Penns Valley 4-H Rams Club
Class Number _2235_
Class Name _Vegetable_ Age _14_
Project _tiger-Red Tomatoes_

THIRD

LEFT
The York Fair displays top prizewinners in the antique competition.

BELOW
A visitor admires the intricate workmanship of handmade quilts at the York Fair.

OPPOSITE ABOVE
Entries in the cake decorating competition at the Bloomsburg Fair look too good to eat.

OPPOSITE BELOW
Ribbon winners in the canned produce competition at the Bloomsburg Fair are exhibited front and center.

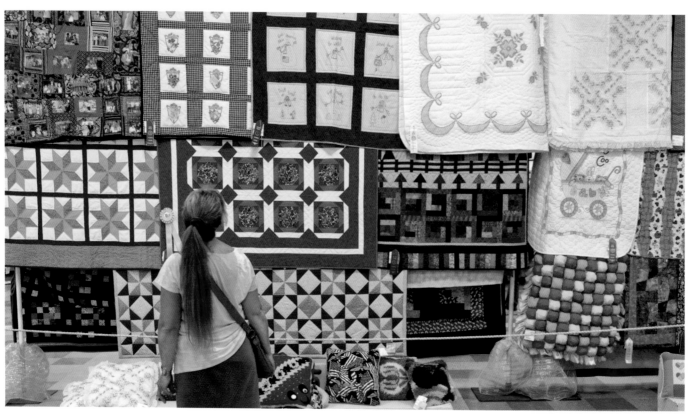

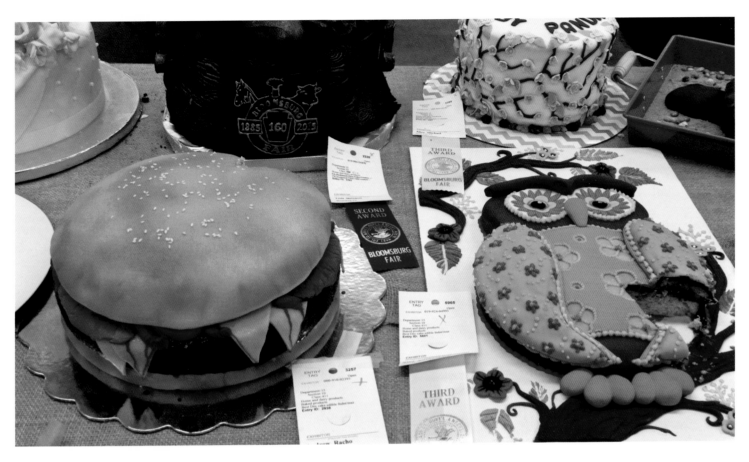

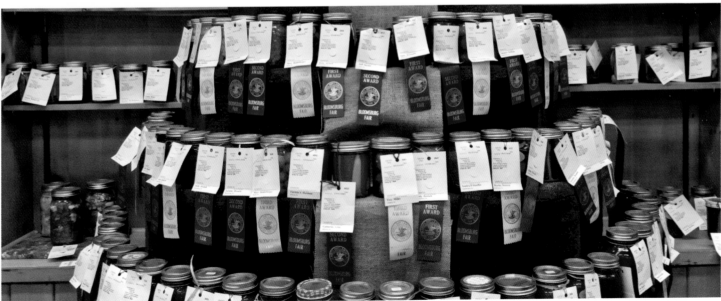

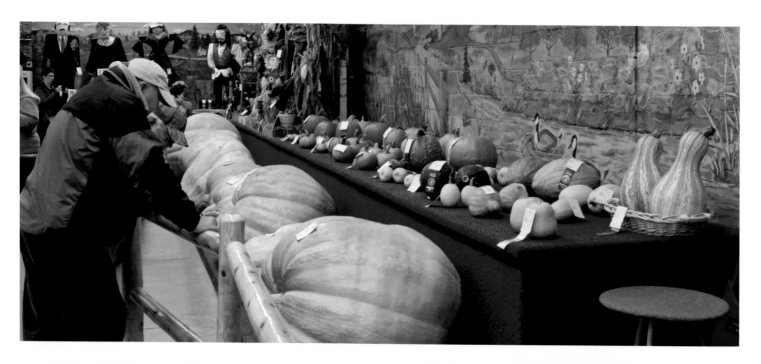
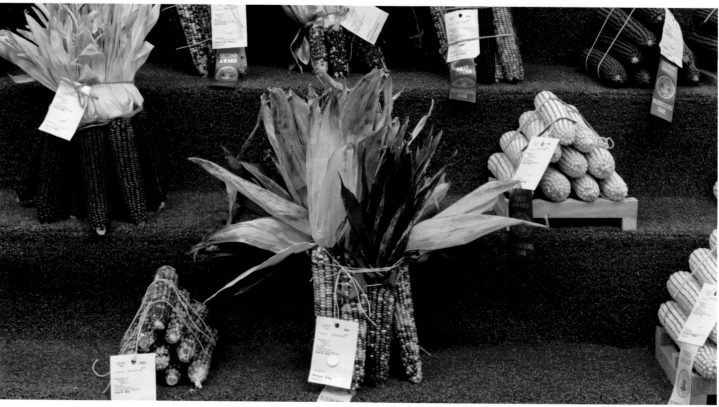

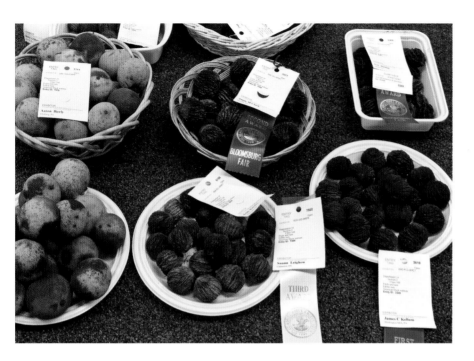

OPPOSITE ABOVE
Visitors get the scoop on how to grow
1,000-pound pumpkins.

OPPOSITE BELOW
The Indian corn competition adds
autumn color to the Bloomsburg Fair.

LEFT
The American black walnut competition
is specific to the Bloomsburg Fair.

BELOW
The cactus and succulent competition at
the Bloomsburg Fair has some of the
finest specimens exhibited anywhere.

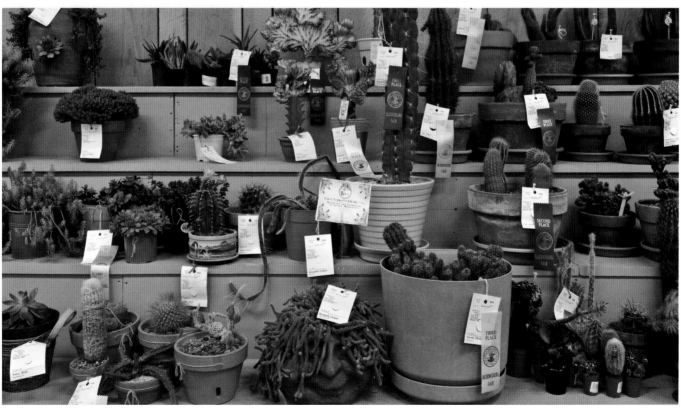

LEFT
A visit to the fair is not complete without sampling the funnel cake.

BELOW
Few beverages are more refreshing on a hot summer day than fresh-squeezed lemonade.

OPPOSITE
Food concession workers put in long days serving hungry crowds at the Wayne County Fair.

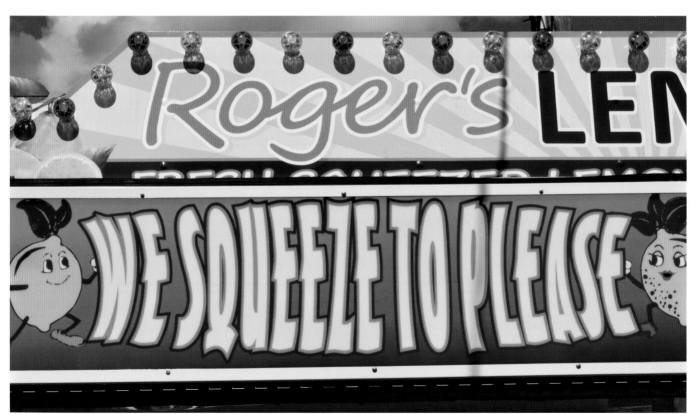

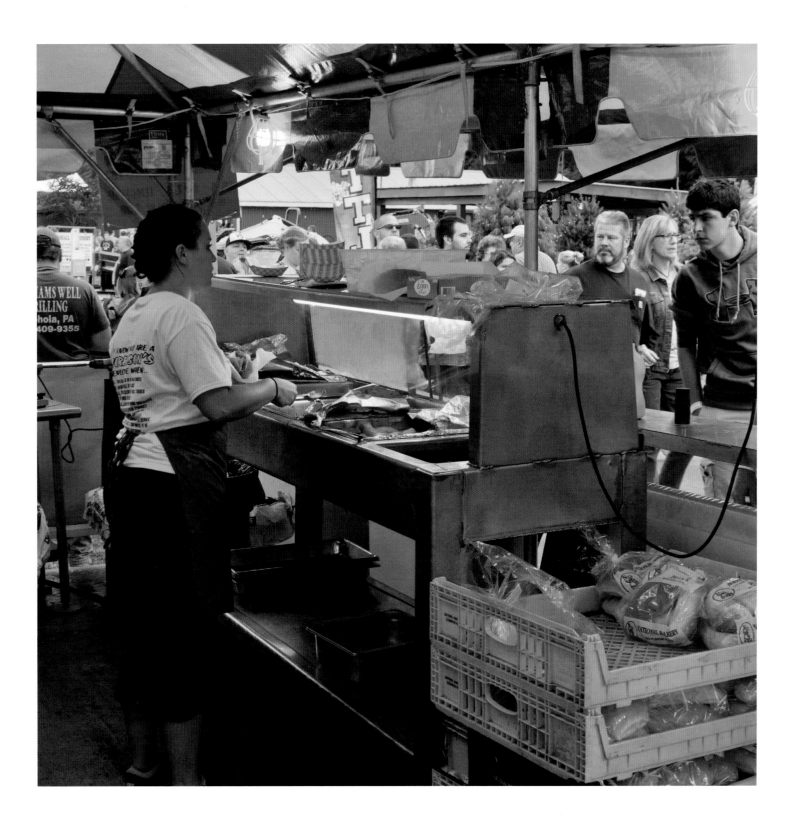

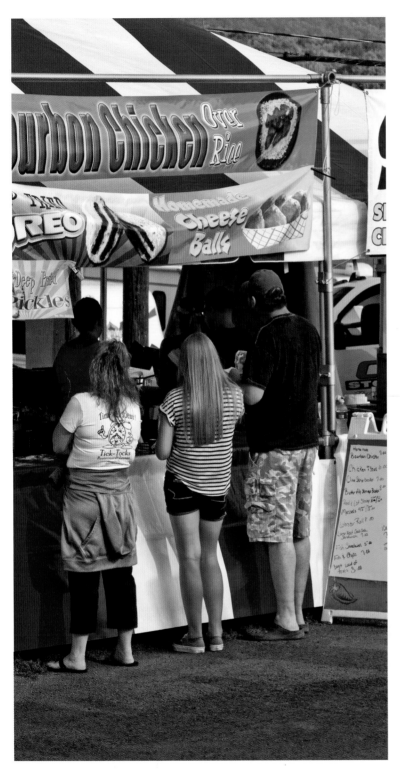
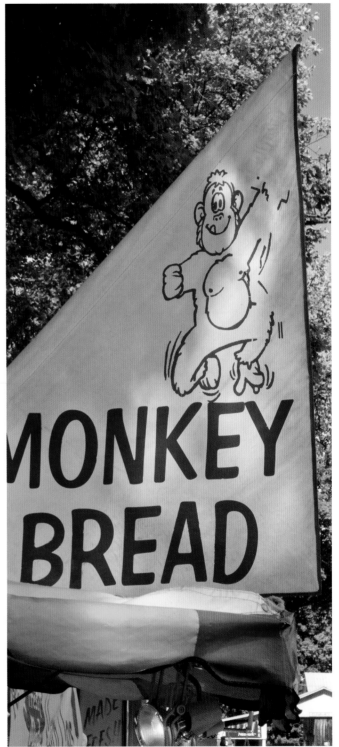

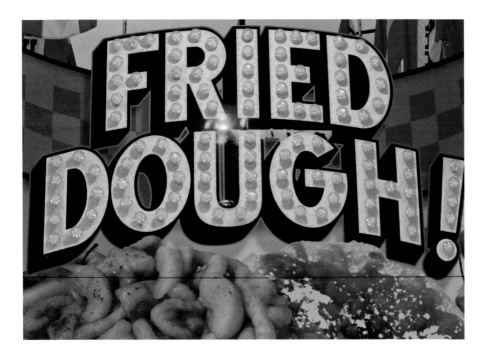

OPPOSITE LEFT
The food choices seem endless.

OPPOSITE RIGHT
Originating in the 1950s, gooey, cinnamon-sprinkled monkey bread is offered at many fairs. Also known as African coffee cake and pinch-me-cake, it is virtually unknown outside the United States.

LEFT
Dieting is put aside during fair week.

BELOW
There is never a lack of food choices at the Allentown Fair.

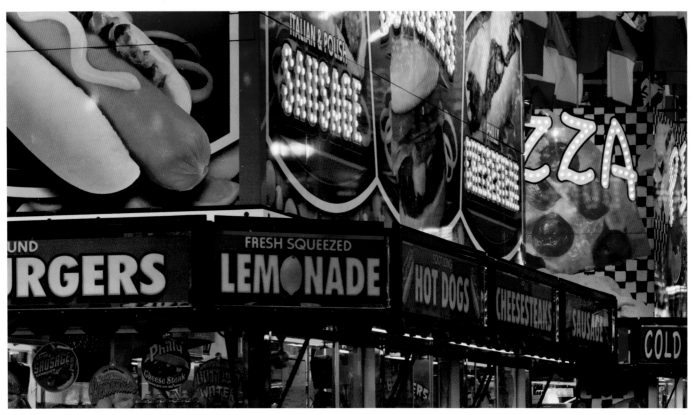

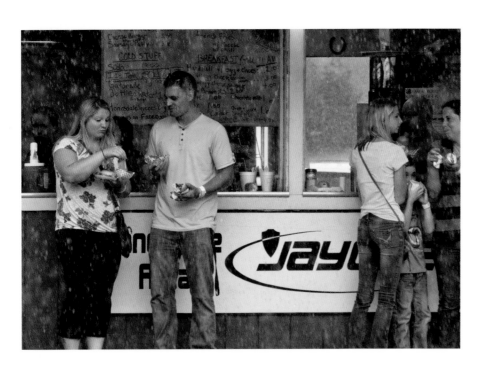

LEFT
Wayne County fairgoers take
shelter from the downpour under
a food concession tent.

BELOW
A food concession worker takes a
break at the York Fair.

OPPOSITE
Security takes a lunch break
at the York Fair.

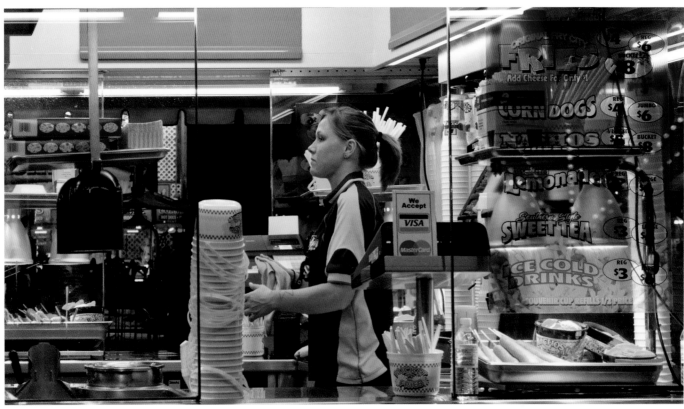

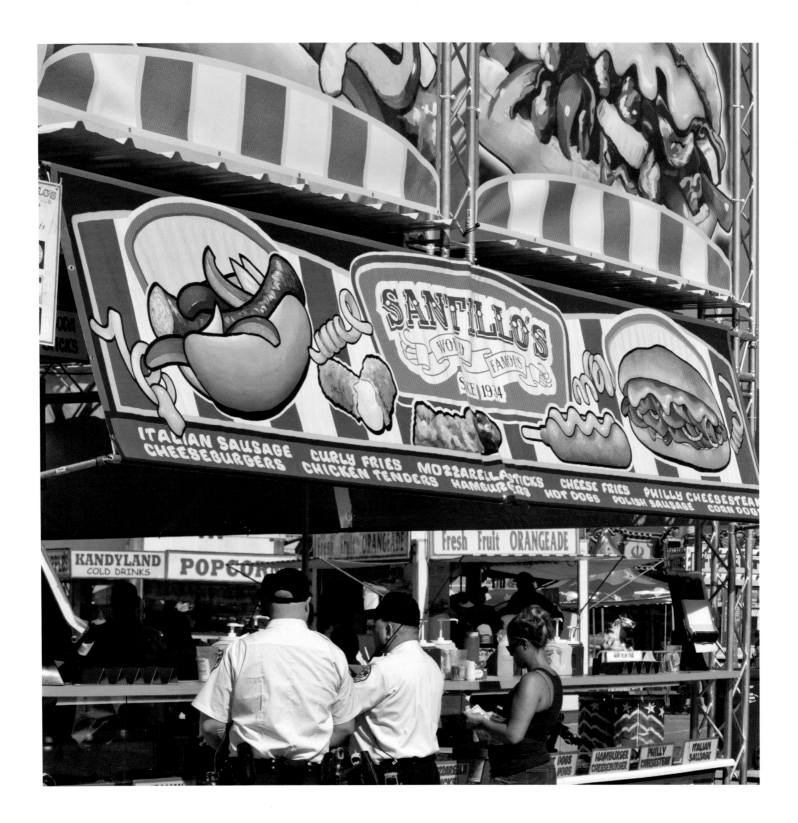

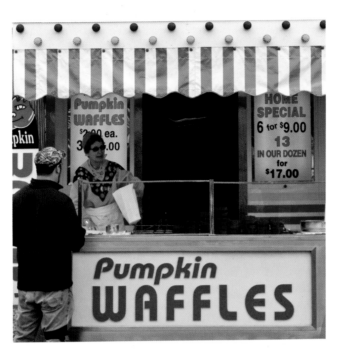

Pumpkin
WAFFLES

OPPOSITE
York Fair's midway lights
cast their spell.

LEFT
A pumpkin lover's dream:
pumpkin waffles with a big scoop of
pumpkin ice cream on top.

BELOW
Pumpkin cotton candy?
Why not?

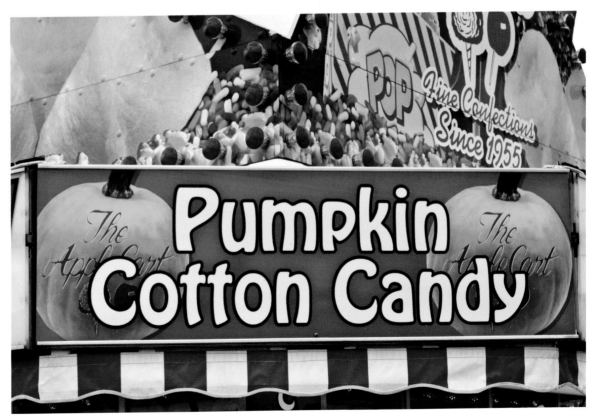

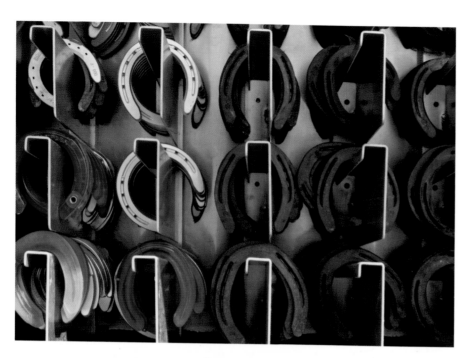

LEFT
The visiting blacksmith at the Lycoming County Fair brings a variety of horseshoes to fit every horse and need.

BELOW
Fairs offer almost every style of fashion for sale, including Western gear.

OPPOSITE
A retailer displays a collection of knitted hand puppets for sale in the commercial area at the Greene Dreher Sterling Fair in Newfoundland, Pennsylvania.

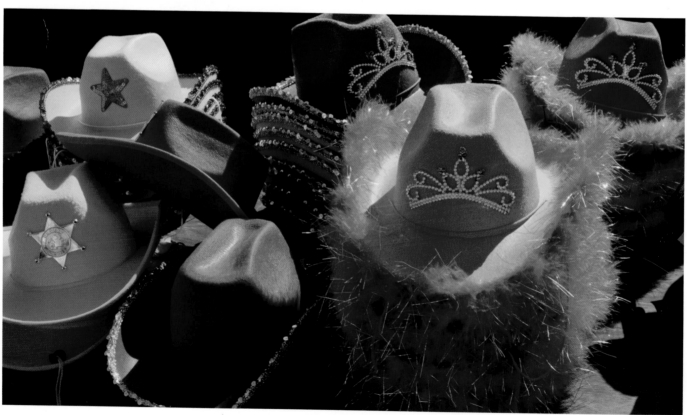

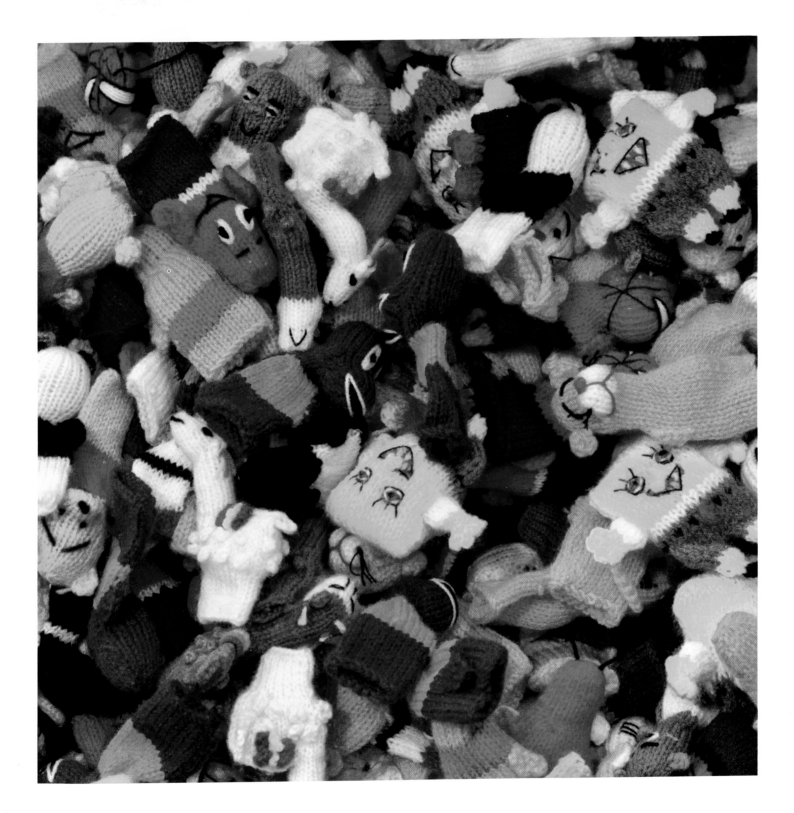

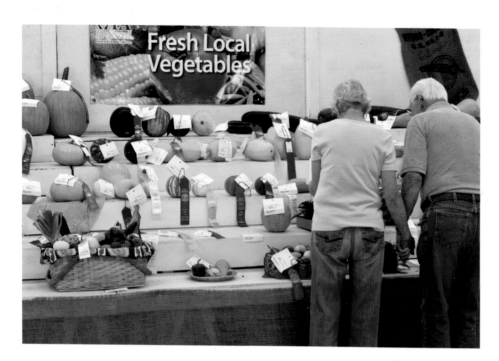

LEFT
Everyone is young and in love
at the country fair.

BELOW
Often called "The Nation's
Most Unique Country Fair,"
the Centre County Grange
Encampment and Fair becomes
a city in itself as families rent and
occupy nearly 1,000 highly decorated
and furnished tents in a tradition
dating to 1874. Additional families
camp in 1,500 personal RVs.

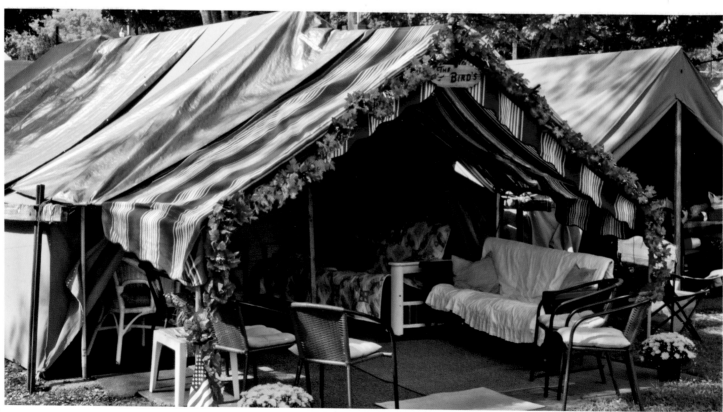